Planning Your Paintings
Step-by-Step

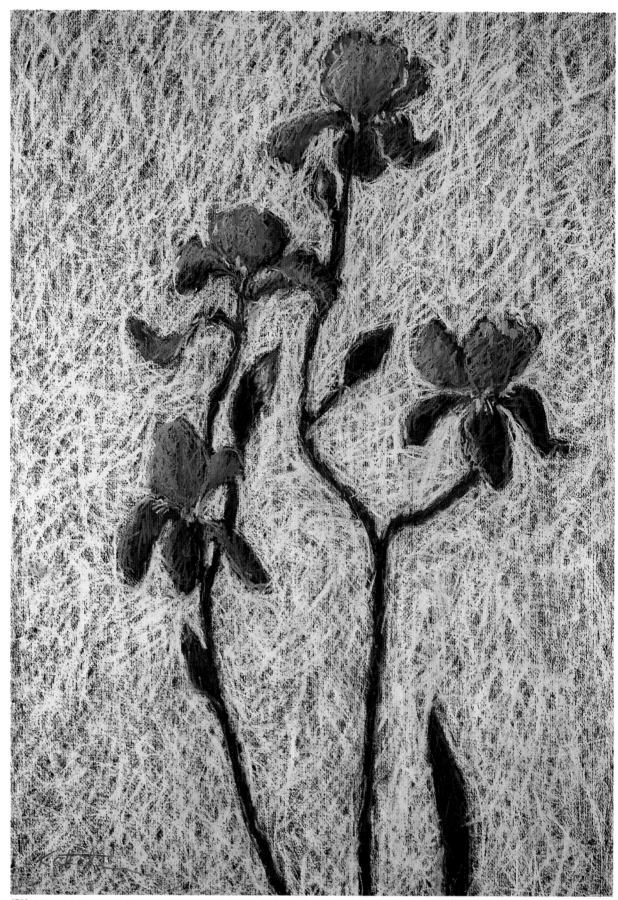

IRIS, 39″ × 27″ (99 × 69 cm), pastel, collection Iris Strom

Carole Katchen

Planning Your Paintings
Step-by-Step

Watson-Guptill Publications/New York

Copyright © 1988 Watson-Guptill Publications

First published in 1988 in New York by Watson-Guptill Publications,
a division of Billboard Publications, Inc.
1515 Broadway, New York, N.Y. 10036

Library of Congress Cataloging-in-Publication Data

Katchen, Carole, 1944–
 Planning your paintings step-by-step/Carole Katchen.
 p. cm.
 Includes index.
 ISBN 0-8230-4022-4 :
 1. Painting—Technique 2. Composition (Art) 3. Visual
perception. I. Title.
ND1500.K29 1988
751.4—dc19 87-30413
 CIP

Distributed in the United Kingdom by Phaidon Press Ltd., Littlegate
House, Ebbe's St., Oxford

Manufactured in Japan

First printing, 1988

1 2 3 4 5 6 7 8 9 10/93 92 91 90 89 88

This book is dedicated to B. Ann Levin, my Aunt Berde,
who taught me about elegance and grace.

With special thanks to Jay Anning, Ginny Croft,
Doug Dawson, Sue Dawson, Janis Delaney, Dan Dulaney,
Gerry Grout, Linda Katchen, Sally Strand, Iris Strom,
and Mary Suffudy.

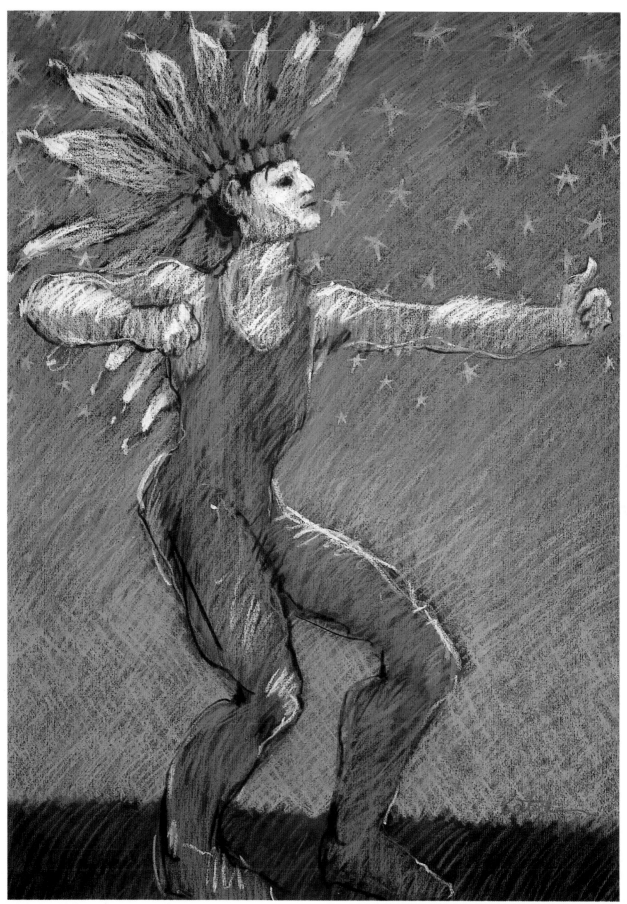

WESTERN STARS—INDIAN, *39″ × 27½″ (99 × 70 cm), pastel*

Contents

Introduction: Why Plan Your Paintings?

For the first several years of my career, I refused to plan my paintings. "I'll lose all of my spontaneity!" I insisted. "All the excitement will be gone!"

So I continued to paint off the top of my head. With no advance thinking, I would set up a model, grab some paper and a few sticks of pastel, and go off on another painting adventure. My paintings *were* spontaneous. The process definitely *was* exciting. And once in a while I created a piece that I was proud of.

The rest of the painting? Well, I would say that 75 percent of my work ranged from "unresolved" to disastrous. Finally after many years of "painting roulette," I decided that there must be a less masochistic way to paint.

Fortunately, I am a writer as well as a painter. So while I was spontaneously hurling myself at my paintings, I was also interviewing other artists who work in a more organized way. They told me how, before they begin to paint a subject, they first complete many sketches, value studies, and color studies. "Bo-o-o-o-oring!" I thought to myself.

Then I looked at these artists' paintings and saw that the finished work did not look boring at all. Well, maybe some of it did—but much of it was rich and vital work. Instead of throwing out 75 percent of their finished paintings, these artists were tossing only 25 percent. A lot of their studies went into the trash, but usually the final paintings worked. There was cause here for reconsideration.

So I began to try some of their methods. I started by making a simple line drawing of the subject before I began to paint, but that didn't seem to make any difference. I tried doing a gesture or contour drawing of the model, which I would put aside before doing a pastel or watercolor of the same model. I was still tearing up 75 percent of my paintings. As far as I could see, all I was doing was wasting drawing paper.

I don't know when the breakthrough came, but one day I realized that there was no connection in my work between the drawing and the painting. I thought I was doing a preliminary study, but I was actually doing a drawing and then an unrelated painting. I still wasn't *planning* the painting.

The other part of my realization was that I was missing a step *before* the drawing. I needed to start *thinking* about the painting before I put even one stroke of pencil on the paper. It seems so obvious now, but after years of painting in a totally undirected manner, I was set in my ways.

So I began to think first about how I wanted the finished painting to look. How did I want the subject to fit on the paper or canvas? What parts did I want light and what parts dark? What parts defined and what parts more abstract?

After some basic decision-making, I then set up the model and did a simple line drawing. Now the sketch was not a mere exercise in drawing, but a preparation for painting. I followed with more studies to develop composition, values, and color. Then when I began the final painting, I was more confident and my painting was more consistent.

Yes, it was less exciting—in the way that walking down a dark alley at night is exciting—but somehow it was even more challenging. I now visualized an image; would I be able to make that image appear on my canvas?

It didn't happen overnight, the change in my approach to painting. As a matter of fact, I still occasionally jump into a piece without enough planning. The results are usually bad enough to convince me to start again with more thought.

That is how I begin now. I spend a lot of time thinking about a proposed painting. I do loose preliminary sketches, composition studies, value studies, and color studies. Only then do I start the final piece.

After all that planning and organizing, what do I do if the finished painting doesn't look spontaneous enough? I do it again. I have found that my paintings look overworked only when I have not done enough preliminary work. When I have resolved most of the problems before I start painting, I can approach the canvas with a looseness and confidence that makes each piece look fresh and spontaneous.

In the following chapters I will lead you through the planning techniques I have developed for myself. Some may work for you; some may not. What is most important, though, is that you learn the process. My intent in this book is to help you develop your own process for taking an idea and, step-by-step, turning it into a finished painting.

Preview
Planning a Painting

Eucalyptus at Sunset is a good example of the steps I go through in planning a painting. When I first moved to Los Angeles, I lived in a house high up on Mt. Washington. From the dining room window there was a wonderful view of valleys and hills, lots of trees, and just a few houses. From the first time I saw the scene, I wanted to paint it. Since I wanted it to be the best painting I could do of the subject, I spent two months looking at the scene, analyzing it, and doing various studies. I didn't even start the final pastel painting until I had done all that preparation.

First I had to consider how I wanted to organize the composition. I decided to use a eucalyptus tree in the foreground to divide the format into a more interesting design, since the view of the hills simply consisted of two large horizontal shapes—the hills and the sky. In the preliminary sketch I placed the tree to the left of center so the composition wouldn't be too symmetrical. I used angular branches to make further divisions and added the less specific shapes of the foliage.

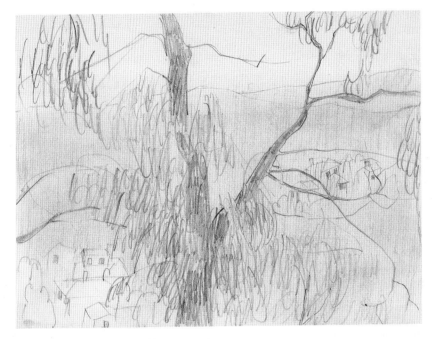

After determining the main shapes, I began to plan their values—the lights and darks. I had watched the view change with the light at different times of the day and decided that the most dramatic effects occurred in the late afternoon or early evening, when the sky was still light but the trees had become dark silhouettes. In my painting the sky would be light, along with the houses and the highlights on the trees. The darkest shapes would be the trees. The rest of the shapes would be middle grays.

I tried placing a tree trunk on the left edge of the picture but saw that it constricted the image. I decided just to suggest additional trees by adding leaf clusters on either side.

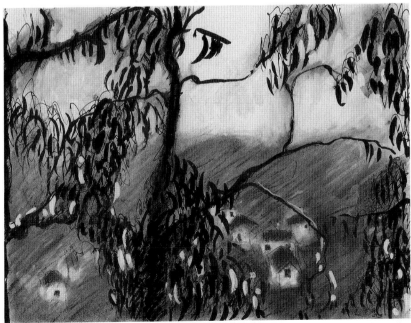

9

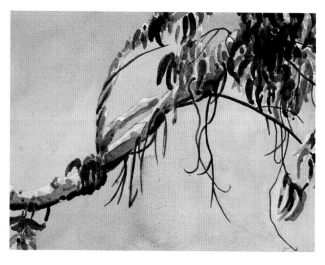

Since the eucalyptus trees were so prominent in the composition, I decided to take the time to become familiar with them. I painted two small watercolor studies of eucalyptus so that I could understand the angularity of their branches and the curves of their leaves. I have learned that the more familiar I am with a subject, the more control I have in rendering it.

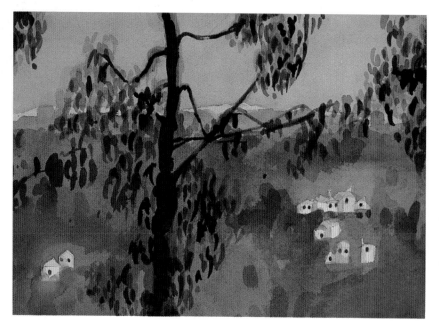

As I watched the light change on the scene, I also noticed the color change. I saw that for fifteen to thirty minutes every evening the sky turned pink and cast a pink glow over the whole valley. I studied the changing colors for several days before taking out my paints. Finally one afternoon I drew the image in pencil, then waited for the color to change. I had to paint quickly so that I could get the basic colors before the sky faded. While I painted, I made mental notes so I could finish the color study from memory.

I used a very simple palette, only rose, purple, and greens. The darkest values resulted from many layers of green and purple washes.

EUCALYPTUS AT SUNSET, *27½" × 39" (70 × 99 cm), pastel*

I used pastel for the final painting because it gives me more variety of color and a more exciting stroke. I decided to use aqua rather than green because I don't particularly like green. I changed the purple to burgundy to create more warmth.

The two qualities I strive for in color are contrast and harmony. The contrast was built into my basic palette—pink, aqua, and burgundy. I also used these colors to sustain the value contrast I had developed in my value study.

I achieved color harmony with my pastel technique.

I built my colors by adding many layers of colored strokes. For example, rather than picking one rose color for the sky, I combined strokes of rose, pink, violet, blue, and yellow. The sky is still pink, but the effect is more interesting than a solid color. The color harmony comes from using the same colors throughout the painting but with different emphasis—touches of blue in the pink areas and pink in the blue areas.

Notice the yellow in the sky, houses, and highlights on the tree. It adds to the color harmony and also conveys a feeling of warm sunlight.

1 Choosing a Subject and Setting It Up

Coming up with an idea for a painting is often more fun for me than any other part of the painting process. First there is an instant of recognition. I am looking at a person or a scene, not really thinking about painting, just seeing what is there, and suddenly I recognize what I am seeing as the subject of a painting. It can be as large as a vast panorama or as small as the shadow of a flower. Something strikes my eye—color, gesture, the shape of an object—and suddenly I see how that image could be captured in paint.

I have never been able to understand artists who complain that they cannot come up with ideas for paintings. Ideas are everywhere; we have only to open our eyes and see what is around us.

The trick is in learning to really see what we are seeing. We become lazy or complacent. We look at a chair and think, ho, hum, there is a chair. Instead, we can look at that chair and see the interesting abstract shapes. We can see how the color and value change as light moves around the form. We can see the pattern of the cast shadow.

When our eyes become sensitive to the world around us, then we no longer have to look for ideas. They are everywhere, and the challenge is simply to choose the ones we like best.

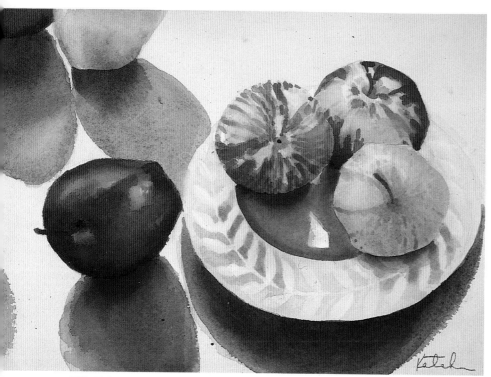

RED AND YELLOW APPLES, 9″ × 13″ (23 × 33 cm), watercolor, courtesy Gallery of the Southwest, Taos, NM

My still lifes always begin with specific fruits or vegetables, which I choose on the basis of shape and color. The design of this piece, for instance, started with the two dappled red-and-yellow apples on the plate, which have an interesting pattern of colors. Then I added the yellow-and-green apple and finally the solid-colored apples for contrast. I included the dish because it added a larger shape and an interesting pattern. Notice that although the pieces of fruit are all apples, each one has a distinctive shape and color.

In planning a painting of fruit or vegetables, I never forget to consider the abstract shape of each piece. The composition must work as a total design of all the forms. Notice in the diagram how the spherical shapes combine to form larger shapes.

Seeing the Abstract Qualities of Objects

I believe that any object can provide the basis for a painting, from the most romantic to the most utilitarian, from roses to paper bags. The secret is to focus not on what the object is or does, but rather on how it looks. Notice its shape, color, texture, and value, its abstract visual qualities.

This is not to say that what the object is doesn't matter. Certainly a painting of flowers has a very different emotional impact from a painting of buildings. However, painting is a visual art, built on the way things look, not what they mean. So when you choose an object to paint, select it first for its visual characteristics.

Let's think about those abstract visual elements.

Shape The subject must have an interesting shape. Since it is going to be the basis of a two-dimensional design, it must divide up the format in an interesting way. If the subject I am considering does not have an interesting enough shape in itself, I then consider if it can be combined with other pieces.

By looking at the elements of a painting as pure abstract shapes, it is possible to see the patterns they create.

One reason I like to paint dancers is that their bodies assume such interesting shapes. It is essential to disregard the musculature, sweat, movement, and costume and see the figure as an abstract form. Then one can determine how it will divide up the format.

Color While color is an integral part of every painting, it can be an exciting enough element in itself to inspire a work of art. The red of a sunset, the purple of a mountain range, the turquoise of the Caribbean Sea—they jolt the eye and beg to be

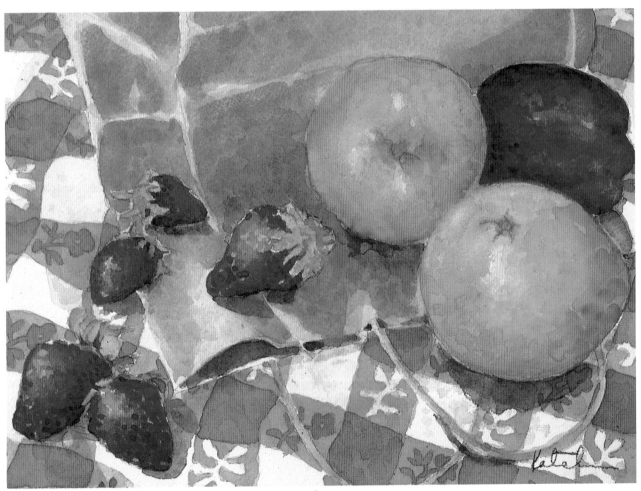

BAG OF FRUIT, *8" × 11" (20 × 28 cm), watercolor, courtesy Gallery of the Southwest, Taos, NM*

In picking objects to combine for a still life, I am not just concerned with shape, color, and texture. I also consider the sense of the painting. Do the objects fit together in a logical way, as they do here? At times I may combine unexpected objects for "shock value," to

make the viewer stop and think about why those things are together. However, I don't want to make the combination so bizarre that the viewer gets totally involved in thinking about the subject and doesn't ever really look at the painting.

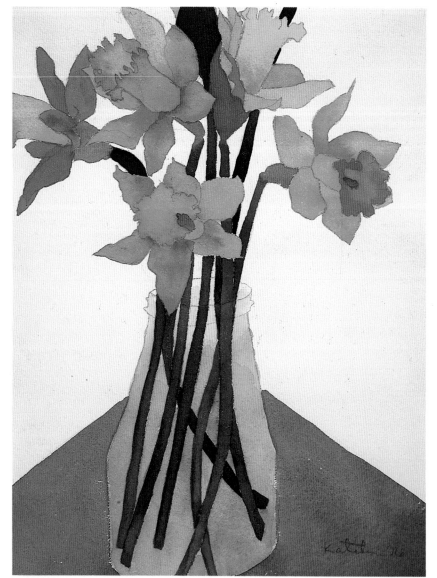

JONQUILS, 14" × 11" (36 × 28 cm), watercolor

It is a mistake to assume that just because a bunch of flowers is beautiful, it will make a beautiful painting. In choosing a subject, look for the abstract design qualities that will make a strong painting. There are two elements that make this painting work. One is the wonderful, rich yellow of the flowers. The other is the strong graphic pattern created by the flowers and their stems. In the diagram you can see the total design created by the abstract shapes.

Suggested Project

Learning to See Objects Abstractly

Make a list of several types of fruits or vegetables that you want to include in a still life, but do not name specific fruits like apples or oranges. Instead, list the abstract qualities that you are looking for. For instance, two smooth and three bumpy objects; four yellow objects and one violet object; two round and three long shapes. As you push your basket down the aisle, don't think apple, radish, squash, but rather think bumpy, round, flat, green, pointed. To paint successful still lifes, you must be able to choose your subjects with your eye rather than your mind.

incorporated into a painting. Sometimes it is a combination of colors that intrigues us or perhaps a profusion of colors. At times the discovery of unexpected color inspires us.

Looking at a cluster of roses in a glass jar, for example, I am filled with a sense of exuberant color. At first glance the colors are rather simple: the roses are either red or pink or yellow, the leaves green, the background and tabletop neutral. As I examine the bouquet, however, I see that there are many hidden colors in the flowers, the leaves, the reflections of the jar. *Roses in a Glass Jar* (page 18) may appear to be a painting of flowers, but it is actually a painting of colors.

Of course, it is not enough that the subject is a pretty or striking color. We have to think of color in the context of the total painting. We have to be able to look at color, like shape, in an abstract way. Look at the pure colors, removed from the subject and background, to see how they will fill your painting.

Gesture or line Gesture is especially important in figure paintings, but it can also be a significant element in still lifes and landscapes. Does your subject have lines that run through the total image? Do they provide a major thrust or movement?

Contrast Can you see areas of differing values in the subject you are planning to paint? A strong visual image generally is comprised of dark areas, light areas, and gradations in between. This value contrast adds greatly to the visual drama of a piece.

Texture Are there facets of your subject that will provide interesting textural changes within the painting? In *Saturday Flowers* (page 35), notice how the flat areas of the background contrast with the small patterns of the flowers.

Visual impact Visual impact is a result of how all the other elements work. When interesting shapes, strong contrast, vibrant colors, and texture all work together, the image will seize the viewer's attention. Look at the subject you are considering. Does it have enough impact to make you want to look at it again?

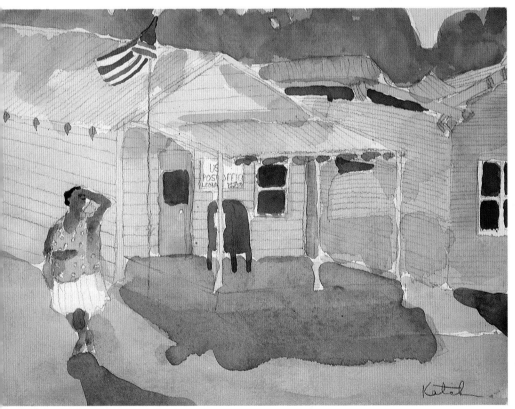

P.O., LEONA, TX, *9″ × 12″ (23 × 30 cm), watercolor*

When painting buildings, it is especially important to look at the geometric patterns of lines and shapes. When drawing the roof, walls, and porch, I pay particular attention to the relationships of shapes and angles. In this piece I was not so much concerned with a quaint old post office as with an interesting arrangement of shapes and textures. Not only does the figure add interest and balance on the left, but its gesture draws the viewer's eye into the painting.

I usually choose watercolor for painting when I travel because it is fast to use and easy to carry.

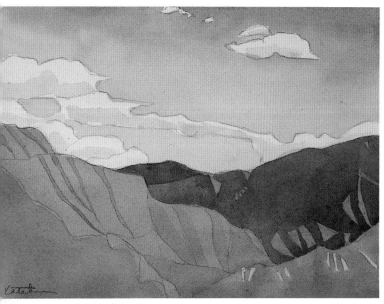

MOUNTAIN STUDY 1, *9″ × 12″ (23 × 30 cm), watercolor, collection Harriet Kelly*

MOUNTAIN STUDY 2, *9″ × 12″ (23 × 30 cm), watercolor, courtesy William Havu Fine Arts, Denver*

The first time I painted mountains, I was a bit over-whelmed, so I started by just looking at them for several days. What I focused on were the relationships of abstract shapes, colors, and values. Usually in any scene that you are considering, there are countless

large and small elements. It helps to simplify the scene by reducing the image to a design of the larger shapes and to eliminate all but the most important details. That is what I did in these two studies, developing them as almost abstract patterns of shapes.

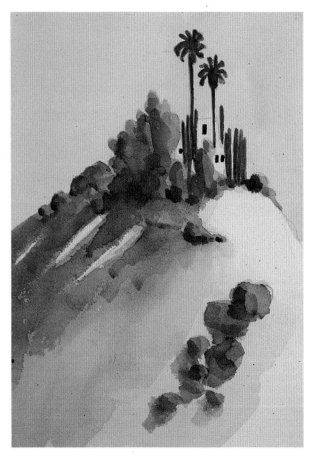

THE OASIS, *20″ × 14″ (51 × 36 cm), watercolor*

The inspiration for a painting can be a mood or feeling about a place, a person, or a situation. This scene was a hill I saw not far from downtown Los Angeles. Its proximity to an urban center made its sense of the exotic even more remarkable. I used the patterns of the trees and buildings to create my basic image, then added strong highlights and shadows to make the scene more dramatic.

For the larger painting I decided to use pastel. I wanted a lot of color to warm up the image, so in the sky, for instance, I combined blues, violets, pink, and gold. Also I felt that less definite shapes painted with a loose, scribbled pastel stroke would make the scene more ephemeral.

THE OASIS, *39″ × 27½″ (99 × 70 cm), pastel, courtesy Saks Gallery, Denver*

16

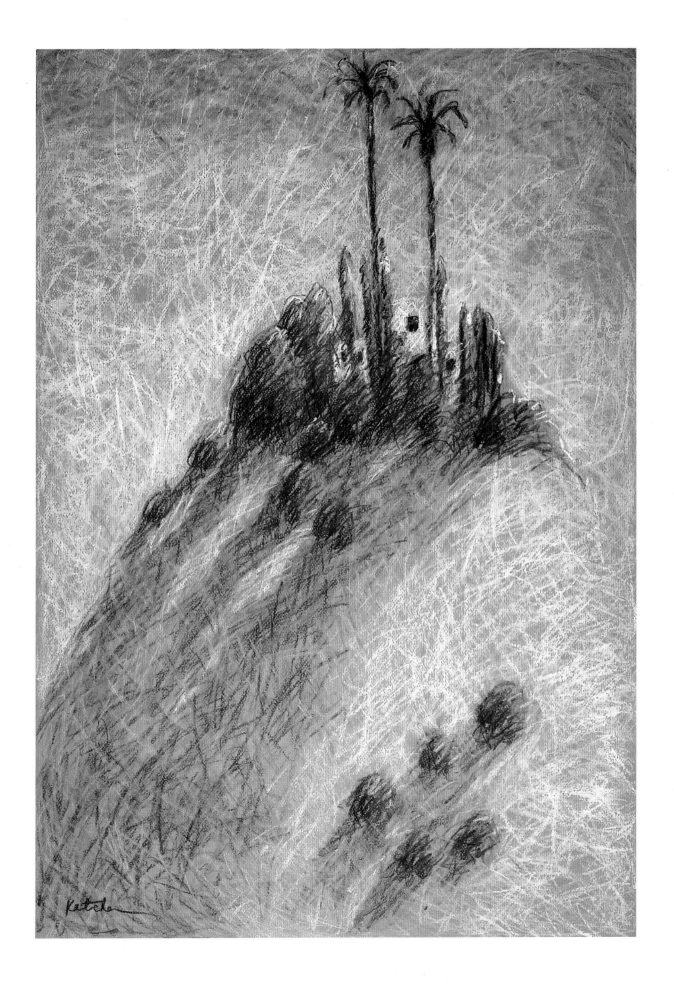

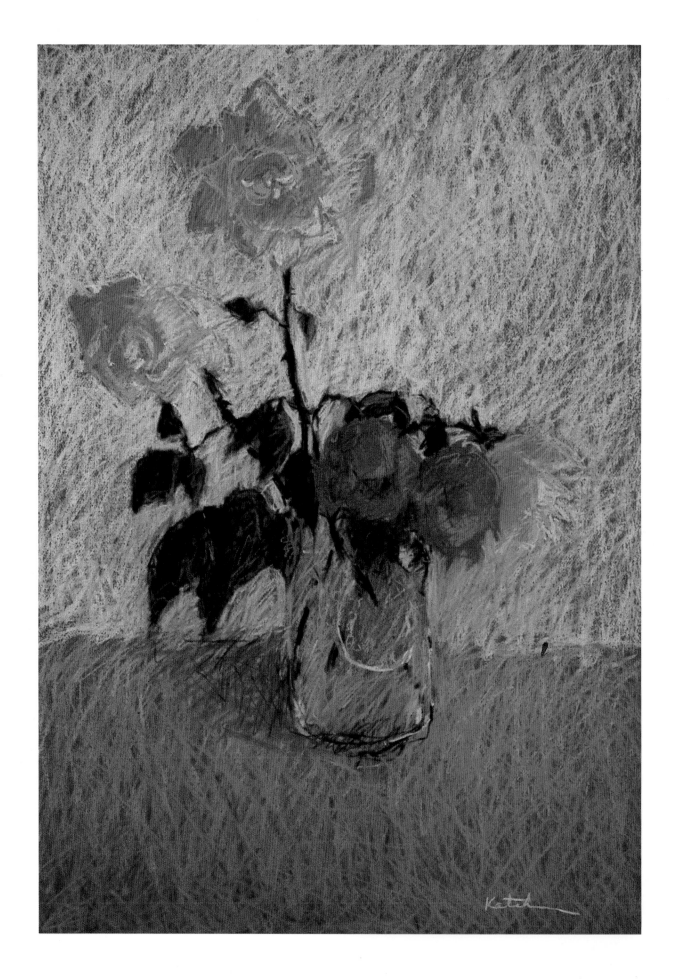

ROSES IN A GLASS JAR,
39" × 27½" (99 × 70 cm), pastel,
courtesy Hooks-Epstein Gallery, Houston

Color is a constant source of inspiration for paintings. Sometimes it is one bold color that demands to be painted. At other times, as in this piece, it is more subtle, almost hidden colors whose unexpected discovery makes you want to paint them. As I studied these flowers sitting on my mantelpiece, I gradually saw more and more colors in the flowers, the leaves, and the glass jar. In my painting I didn't try for a literal representation of what I saw, but used the subject as a jumping-off point for an imaginative display of color.

Suggested Project
Exploring One Subject

Some years ago I saw a series of large paintings that Denver artist Karen Nossaman developed from one amaryllis bulb. She planted the bulb and then painted the amaryllis in each stage of its growth, from the first green shoot to the full-blown flower. I was amazed to see such a simple idea become a total exhibition.

This project requires a bit less involvement than growing an amaryllis. Choose a flower bud, either one that is about to bloom in your garden or a cut flower like a rose or tulip. Sketch it when it is a tightly closed bud. Then do several more studies in black and white or color as the blossom opens to its fullest state. You can do all your studies with the same light, composition, and medium, or you can try several different approaches.

Don't rush through this. The purpose is to take your time and learn to explore one subject. By the time you finish, you should have developed a close relationship with the flower. You should be familiar with its form and color, the shadows it casts, the subtle changes it shows as it opens. This exercise will help you see any new subject in many ways.

Recognizing Abstract Qualities in People

What makes a person a good subject to paint? It can be the person's appearance or activity. It can be some element of gesture or personality. It can be the way that the person interacts with other people.

Sometimes I select a human subject just because of one small aspect—a gesture, an expression, a physical feature. When you choose one aspect of a model as the basis of a painting, be sure it is something visual. I might be attracted to a person because he has a beautiful speaking voice or is brilliant or is kind and generous, but these qualities won't work for a painting. As an artist, I must be more concerned with how he holds his hands, the line of his posture, the expression of his eyes—the things that are visual.

Often the people I know best become subjects for paintings. Close friends or relatives are often available for modeling, which is a great advantage. Besides, I am already comfortable with them and familiar with their appearance. When you know your models well, however, you can take their appearance for granted, assume you already know what they look like. As a result you can end up painting what you think they look like and not what you actually see. Another problem can be trying to please a friend with a flattering image when you would be better off concentrating on creating the best painting you can.

People you don't already know can provide more of a challenge. Many of my best subjects have been strangers I have seen in my own environment or people I have seen while traveling. The challenge is to capture the appearance as well as something of the personality, activity, and situation of an unknown person in a limited amount of time.

I am the kind of artist who is always intrigued by the unusual. I have spent much time traveling and painting in Africa and South America, and even at home my fingers itch for a pencil whenever I see an exotic-looking person. I have learned, however, that just as everything beautiful does not make a good painting, neither does everything odd. Again it is necessary to see with the eye rather than the mind. I might be fascinated wondering who is this person, why is he dressed that way, what in the world is he doing, but I must suspend all that when I choose a subject to paint and be more concerned with the visual aspects of line, shape, and color.

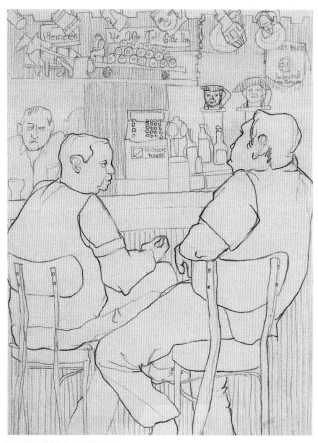

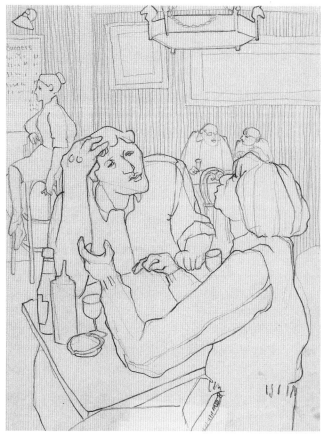

YE OLDE TAILGATE, *12″ × 9″ (30 × 23 cm), pencil*

WHITE HORSE TAVERN, *12″ × 9″ (30 × 23 cm), pencil*

Interior scenes and exterior scenes present much the same problem: to take a complex three-dimensional view and turn it into a simple pattern of two-dimensional shapes. In these two drawings of the interiors of taverns, I picked out the largest shapes first, then added just enough smaller shapes to complete each image. Details were important for conveying the ambience of each scene, but I limited myself to those that were vital. People were treated as abstract shapes to be included with other elements in the overall design.

The focus of this painting is the conversation between the two large figures in the foreground. The situation is an intense discussion between an older woman and a younger man in a Greenwich Village bar. Because the interaction of the figures is key, I made them the largest shapes and included only enough details around them to give a sense of where they are. As with all my figure paintings, body language is stressed. Look at the hands, how much they alone tell about the situation.

The diagram at left shows how all the elements of the painting fit together when they are observed as abstract shapes. In a scene like this, both the human figures and the inanimate objects should be considered for their contribution to the overall design.

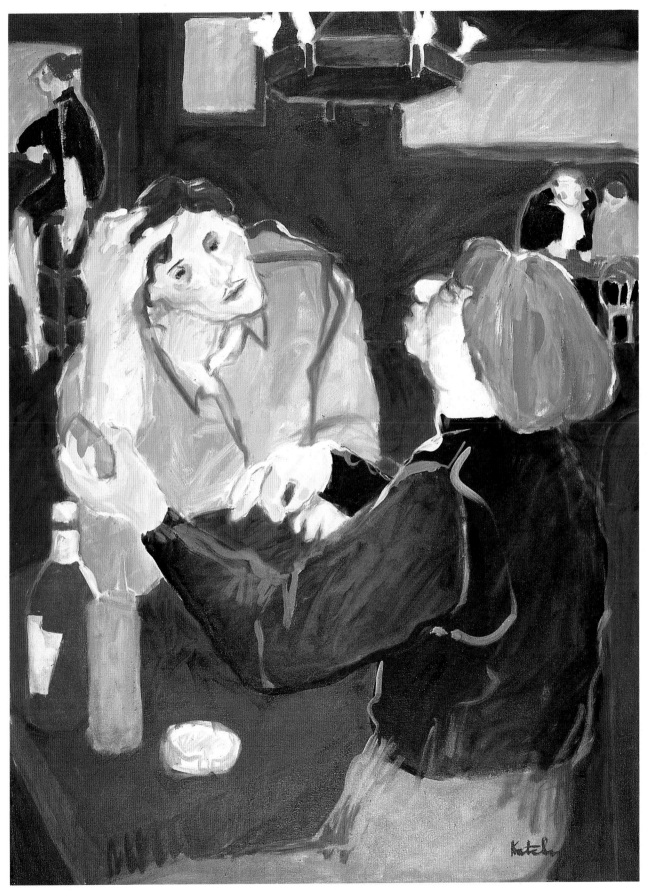

WHITE HORSE TAVERN, *48" × 36" (122 × 91 cm), oil, courtesy Gallery of the Southwest, Taos, NM*

Sometimes what makes a person an interesting subject is an external element like clothing. Two of my favorite pastels of people, *Colleen in a Red Hat* (opposite) and *Gretchen and Roses* (page 26), were inspired by the hats people were wearing. Hats are especially useful because they add an interesting shape to what is usually just a plain oval for a head. Also they can add dramatic value changes by shading the face. Similar visual elements like the flowered texture of a dress or the flowing lines of a coat can be important to the design of a painting.

Props can also be useful. Once I had a commission to paint several small watercolor portraits of a young girl. I painted Corinne feeding the ducks; I painted Corinne eating an ice cream cone; I painted Corinne looking out a window. In each case there were props that provided the key to the image. My favorite, *Corinne with an Umbrella* (page 32), was basically a cute picture of a little girl in a bathing suit until I added the umbrella; the exciting shape of the open umbrella added the strong design element that made it a solid painting.

Sometimes it is the activity of a person, whether unusual or mundane, that can be the inspiration for a painting. The function of an activity in a painting is to provide greater focus and movement. A model sitting straight in a chair, looking directly at the artist, is usually a much stiffer, less involving image than the same model curled up reading a book or bent over tying a shoe.

Theatrical performers are wonderful subjects because their movements, poses, and expressions are so extravagant. I especially enjoy painting musicians and dancers because the gestures of their bodies tend to reflect the music around them. It is important, however, to avoid painting movements for their own sake. No matter how dramatic a dancer's leap is, it must be used as a vehicle for line and form.

The final element that makes me choose people as subjects is the way they interact with one another. A person alone can appear lifeless, boring, but put him in a situation with another person or a group of people and all sorts of interesting things can appear.

What we are looking for here is not verbal conversation, but rather, body language. Are the people leaning toward or away from one another? Are they looking intently into each other's eyes or staring away? Are their bodies rigid or relaxed?

Their postures are important not only for the lines and shapes they create, but also for what they reveal about the human interactions. When drawing one person, we use the elements of the body to build the composition. Similarly, when we draw groups of people, each body becomes part of the total visual pattern. The shapes and gestures create visual harmonies and tensions that reflect the emotional harmonies and tensions that are occurring between our subjects.

The model for this piece was a good friend who I knew would not be offended if I painted something other than a close likeness. Consequently, I felt free to stylize her body, stressing its angularity. Being familiar with Colleen's appearance and personality already, I was able to focus on her contemplative mood. These are some of the advantages of painting a model who is familiar.

Even in a formal portrait I am concerned about whether the figure is an interesting shape that will enhance the total design. In the diagram notice the shape that appears when the figure and negative space are divided into two abstract forms.

COLLEEN IN A RED HAT,
39" × 27½" (99 × 70 cm),
pastel, collection Colleen Sullivan

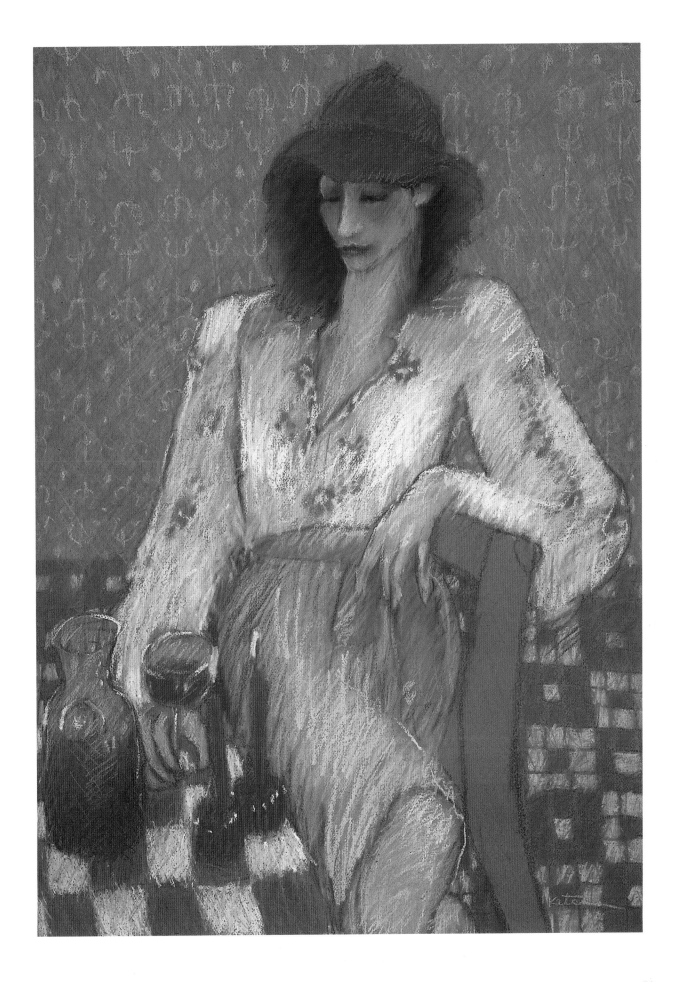

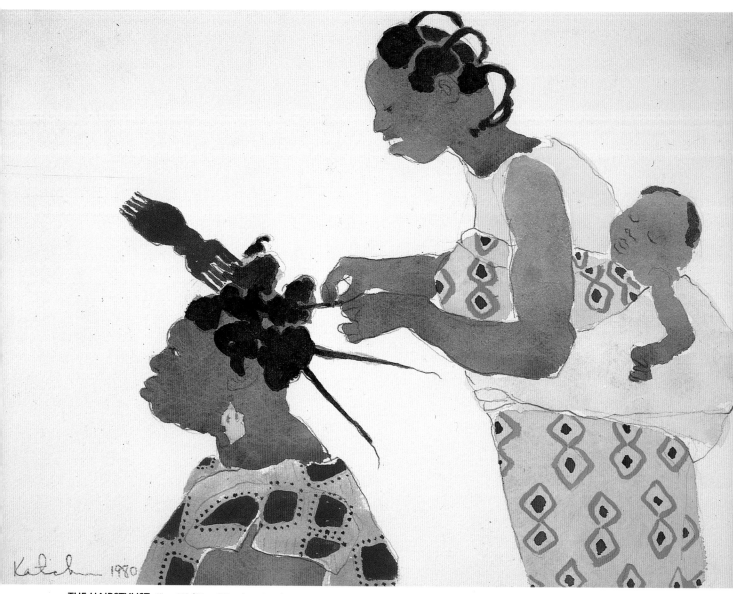

THE HAIRSTYLIST, *9" × 12" (23 × 30 cm), watercolor*

These four sketches were done during a trip to Nigeria in 1980. I spent six weeks in the West African country, drawing and painting in preparation for a suite of etchings I was commissioned to execute. I took pencil, ink, and watercolor supplies with me—but no camera. I have learned that if I take the time to draw or paint whatever I want to remember rather than photograph it, I retain not only the visual image but also the smells and sounds, the heat, all the important details of the place.

The challenge of drawing people you don't know, especially in candid studies like these, is to capture the person's appearance and situation in a limited amount of time. You must be very selective about what you include. In Beach Vendor, for instance, I first drew the central figure, concentrating on her costume and posture, her baby, and the bundle on her head. Then I added her surroundings, simplified of course, light washes for the sky and sand, and a group of tourists on the beach.

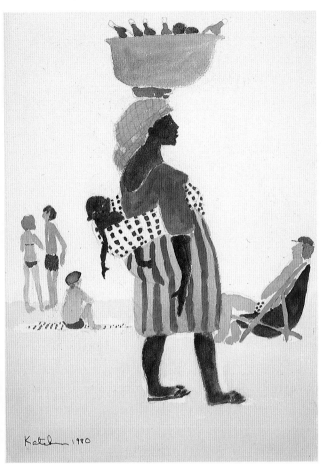

BEACH VENDOR, *12″ × 9″ (30 × 23 cm), watercolor*

WOMAN IN A DOORWAY, *8″ × 5″ (20 × 13 cm), ink,*
collection Mr. and Mrs. Tim Cisneros

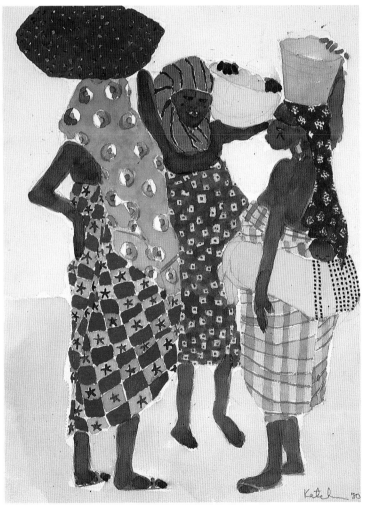

FULANI WOMEN, *14″ × 11″ (36 × 28 cm), watercolor*

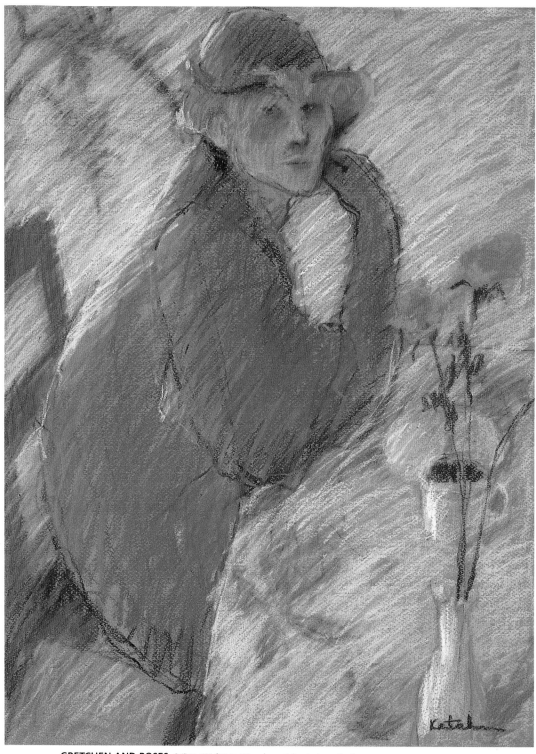

GRETCHEN AND ROSES, *24″ × 18″ (61 × 46 cm), pastel, private collection*

This painting was inspired by a hat. I had seen Gretchen at an art opening wearing this hat and asked her to model for me. I set up the table and background to look like afternoon tea; I wanted to enhance Gretchen's look of being from another time and place. Her hat and coat were actually black, but I decided that blue would work better with the mood of the piece. I also added the long blue glove. I often change elements of reality to create a stronger painting. Although the hat inspired the painting, it became only one of several elements that contributed to the piece.

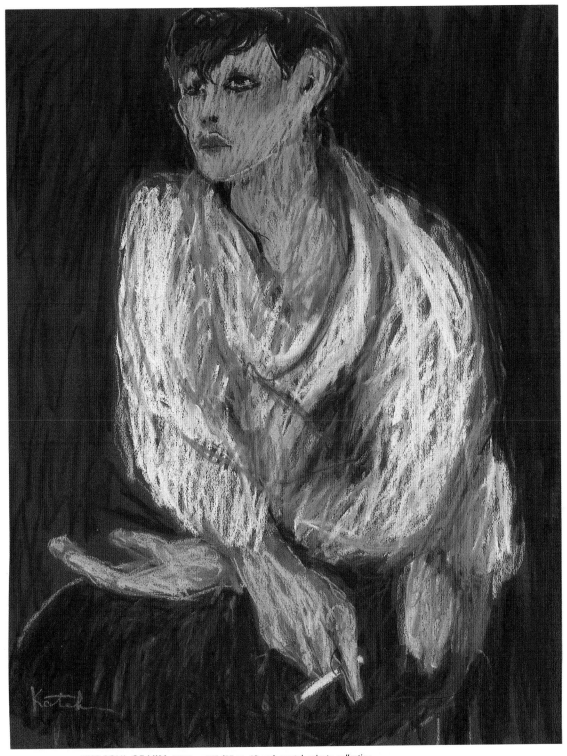

THE SOUL OF LILY, *25½″ × 19″ (65 × 48 cm), pastel, private collection*

This painting grew out of my interest in one characteristic of the model. Lily was a punk rocker with a streak of magenta dye in her hair. It was that feature that caught my eye first and made me want to paint her. As we worked together, however, I became intrigued by the contrast between her large, solid body and her wistful facial expression. In the final painting the magenta hair is apparent, but only in a minor way.

ZACH'S IN THE AFTERNOON, *20″ × 24″*
(51 × 61 cm), oil,
collection Terrence Connor

Body language is the focus of this painting. We first notice the interaction between the central couple: he is looking intently at her while she looks away. His posture is more upright, showing interest; she is more relaxed, unconcerned. In addition, there are smaller figures in the background who are showing their interactions with each other and the total scene. I included the large painting in the rear right because it also was of a very expressive figure.

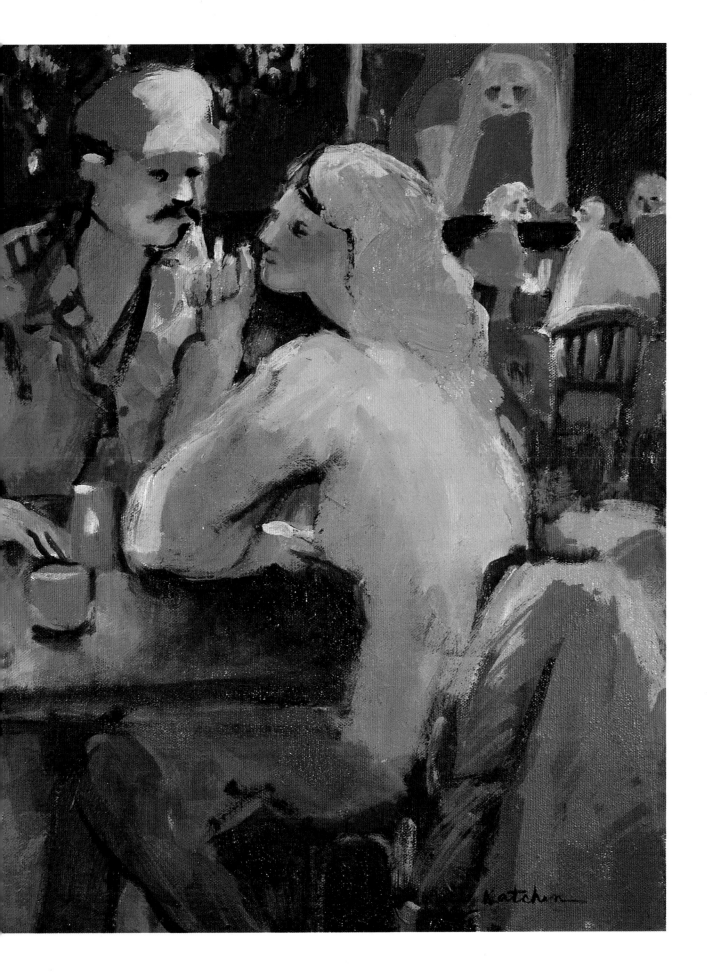

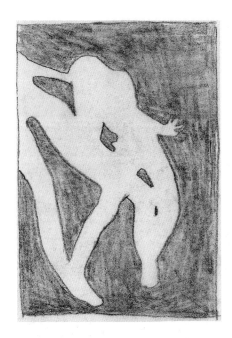

I chose to paint this image of Cleo Parker Robinson because of the intriguing abstract shape of the dancer and her cast shadow. This particularly angular pose divides up the format in a strong way. In the diagram above, I have filled in all the negative space around the dancer and her shadow to show the abstract design.

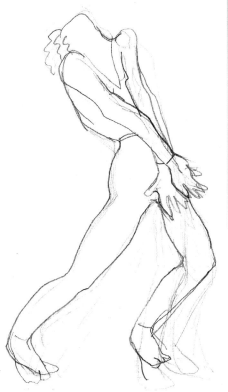

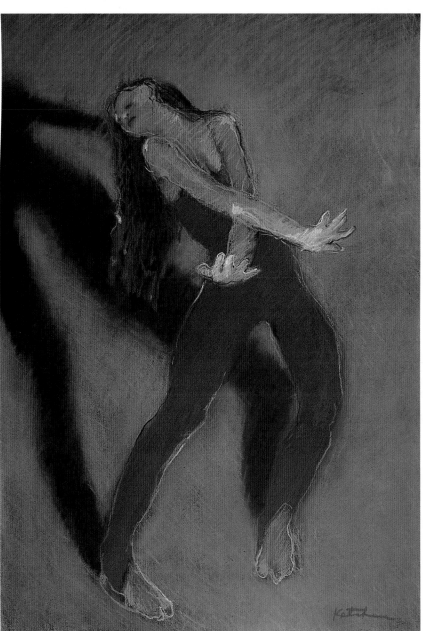

CLEO IN RED, *39″ × 27½″ (99 × 70 cm), pastel*

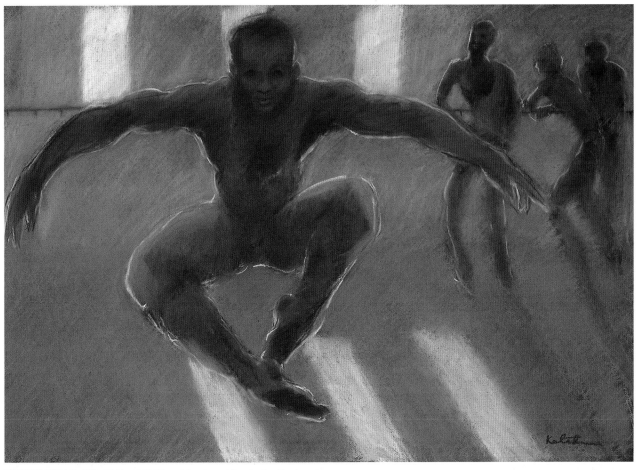

RONNIE IN THE AIR, *27½" × 39" (70 × 99 cm), pastel, collection Northwest Community Hospital, Arlington Heights, IL*

I often visit a dance studio to practice drawing figures in motion and work on the challenge of capturing split-second movements. The quick gesture drawing is of Ronnie Whittaker, a dancer with the Cleo Parker Robinson Dance Ensemble. The movement and shape of the body here were interesting, but did not justify an entire painting.

I looked at the pencil sketch of Ronnie for months, not knowing quite what to do with it. Then I began to study Edouard Vuillard, who painted many figures against a back light. In this painting I showed the studio bathed in light, then added the leaping figure in darker colors, making it almost a silhouette. I put in some smaller dark figures for balance and additional interest. My final step was adding the dramatic bright halo around the figure.

The diagram shows how the contrast between light and dark make the painting work. It is partly the abstract pattern of shapes of different values and also the unexpected light in the background, but not on the figure.

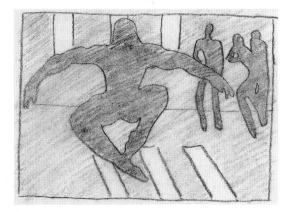

Choosing What Interests You

These are the visual elements you should look for in considering a subject for a painting. In addition there is the factor of your own personal interest in the idea. Is the image one you care enough about to develop into a finished painting?

Sometimes I am tempted to paint something just because it looks like it should be a painting—even though it is something I don't particularly care to paint. I might see an image that reminds me of a painting by one of the masters, or I might notice a subject that looks like what a friend of mine might paint. Those are good ideas for somebody, but not necessarily for me.

I have learned to paint only those things that evoke a strong response in me. The process of completing a painting can be a long, demanding one. I must be deeply committed to a subject; otherwise I may give up the piece before it is done or force myself to finish a lackluster painting.

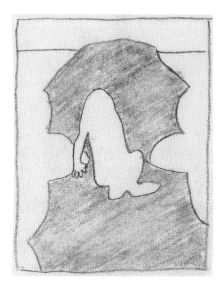

This is an example of the effective use of a prop in developing a composition. The picture was just a simple portrait of a cute little girl until I added the umbrella. You can see how the umbrella and its cast shadow divide the negative space into a design of interesting shapes.

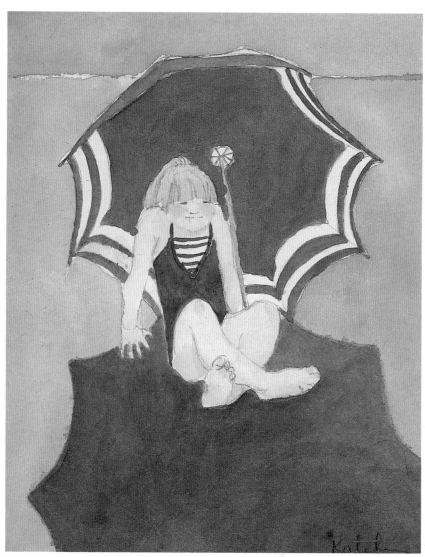

CORINNE WITH AN UMBRELLA, *10" × 8" (25 × 20 cm), watercolor*

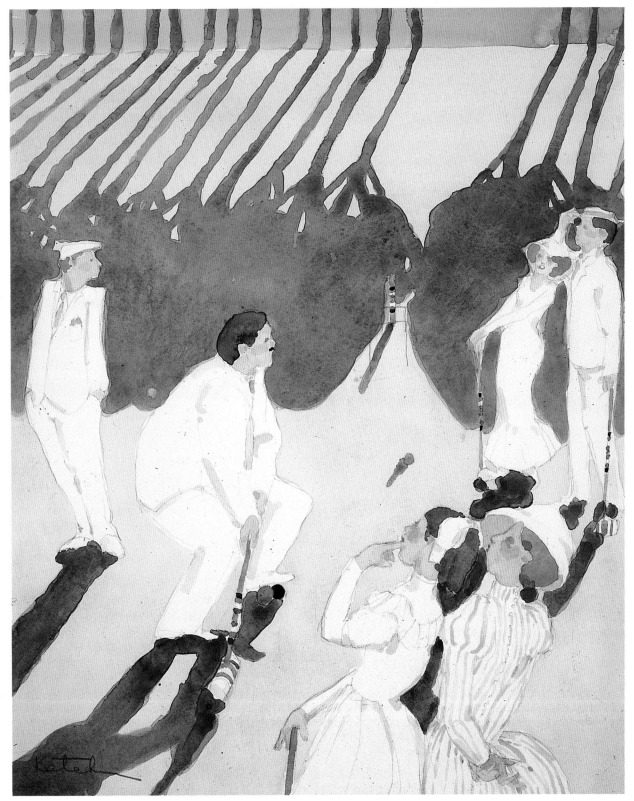

THE CROQUET PARTY, *20″ × 16″ (51 × 41 cm), watercolor, collection Frank Ooms*

It was light that changed this scene from just a nice image to an exciting one. By waiting until the late afternoon sun cast long shadows across the lawn, I was able to create a strong pattern of lights and darks. A lively design is created just by the shadows themselves.

Setting Up the Subject

Okay, your idea is a good one. How do you turn that idea into a solid image? And what is the difference between the idea and the image? The idea is usually nebulous, a thought or a concept. My idea might be to paint a sunset or four oranges or a dancer leaping across a stage. I have a sense of color and shape, but it is undefined.

For the solid image I put a frame around the subject. I see how the main shapes fit into a painting format. In my mind I fill in all the elements I need for a total composition.

Whenever possible, I create a physical setup of the subject. Then I begin my first studies, simple, loose sketches to help me visualize how all the elements will fit together. I start with the main object or figure, then build around it with background, props, lighting, and so on. Even when my idea hinges on an intangible like lighting or composition, I start with something solid.

Remember, we are concerned here with abstract shapes. When I arrange a bouquet of flowers for a painting, I am not thinking about a pretty centerpiece for the table, but rather, what kind of two-dimensional shape I am creating.

Once I have the most interesting shape for my main object, I concern myself with the setting for it. In some cases the object has such a strong shape and color that anything but a simple background would detract from it. In other cases it needs additional elements to make it a complete image, like the cloth in the painting *Basket of Lemons* (page 43) or the chair in *Saturday Flowers* (opposite). In choosing background and props, I am again primarily concerned with the design elements of shape, color, value, and texture.

Usually the only way I can know how all the elements will work together is to experiment. I place my subject and then introduce various additional elements into the format, always looking to see the effect of all the pieces on the total design. To help clarify the image, I use a cardboard frame to study the scene from different distances and angles. It is important not to be lazy about getting up and moving around the subject. My subject for *Apples and Pears* (page 41) was rather unexciting until I looked at it from above. Then the deep shadows in the dark bowl added an element of drama that made the simple subject worth painting.

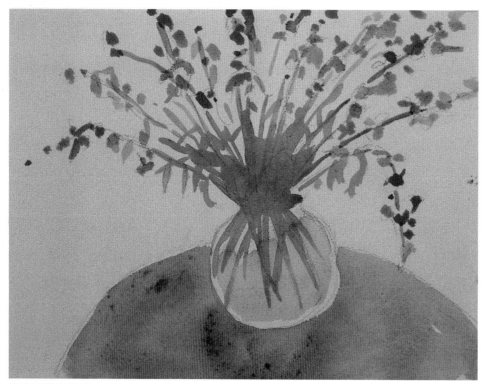

This bunch of delphiniums caught my eye in the store because of the intensity of their blue color. I thought they would be a good subject for a painting, but when I spread the blossoms out in a vase, the color became diffused and much less exciting. With just the blue, green, and brown against a white background, I decided I needed more color.

DELPHINIUMS, 9″ × 12″ (23 × 30 cm), watercolor

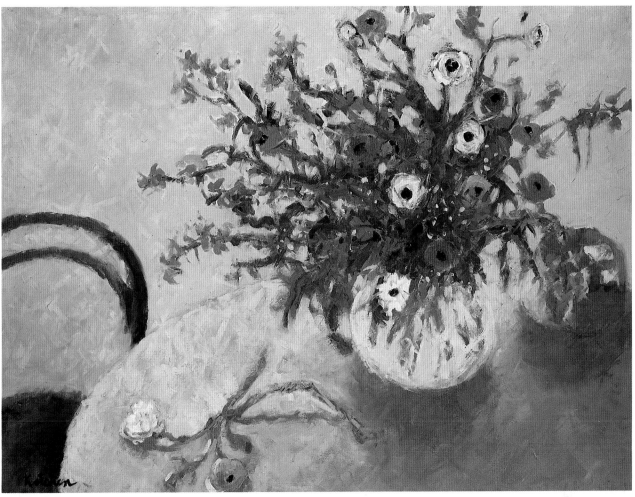

SATURDAY FLOWERS, *36" × 48" (91 × 122 cm), oil, courtesy Lizardi-Harp Gallery, Pasadena*

You can see the changes that occurred in my plans for this image by looking at the initial color study, Delphiniums, *and comparing it to the finished oil. I had started with the simple idea of blue flowers. Then, when I set them up, I saw that the color was flat, so I added more colorful flowers. Then I saw that I had too much empty negative space so I included more objects in the total image. It is quite common for an idea to go through many changes as you develop it into a solid image.*

The simple abstract color sketch at right shows how the colors of the subject move through the entire image. It is not enough to plan the color for just the main object; there must be harmony and contrast throughout the whole piece. You achieve this by looking at color in an abstract way.

Here we see that the main subject of Satur-day Flowers does have an interesting shape but, by itself, leaves too much empty negative space.

Adding more objects creates a stronger overall design. It is important not to add too many objects to any composition be-cause you don't want to turn a barren composition into a cluttered one.

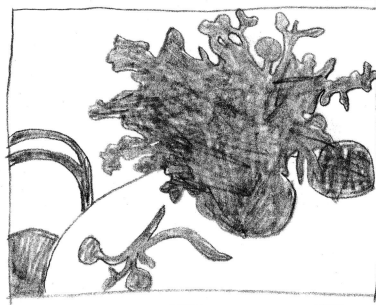

One source of movement in Saturday Flowers is provided by the gesture of the flowers with their outward thrust from the center.

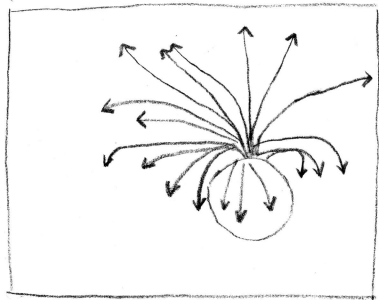

Movement is also provided in this piece by the many curved lines throughout the composition.

Here we can see that Saturday Flowers *comprises areas of contrasting values. There is great variation—from the darks in the chair and in the details of the flowers, to the very light vase and blossoms. Value contrast adds vitality and drama to a painting.*

Notice how the large area of flowers provides such an interesting texture. The pattern of small broken strokes adds a needed contrast to the large flat areas of the background.

Setting Up People

Working with a human model involves very much the same process as setting up a still life. You start with the central figure, finding the most interesting shape as the basis of your composition. Then you arrange the background and props. Finally you set the lighting.

Generally the key to setting up a composition with a figure is selecting the pose. In considering a pose, first I try to see the total body as one large shape. I want this shape to be interesting and also to work well within the total composition. Next I look at the pattern of smaller shapes within the body. Regardless of whether the viewer recognizes that this is a human form, he or she should be attracted to it because it is an interesting arrangement of shapes.

It is important that the position of the body fit into the context of the total picture. If Gretchen is having afternoon tea, she should be sitting in a graceful, relaxed position. If Ronnie is leaping into the air, his body must show tension. If I paint a dancer who is rehearsing or performing, I want the pose to express movement and strength. If the same dancer is taking a break, I want the body to show relaxation, perhaps exhaustion. The right pose is necessary to establish the sense of what is going on.

I try to be conscious of a model's natural posture and gestures and to use those in my paintings rather than some preconceived pose. When I work with a new model, I like to start by taking some time for a chat. This gives both me and the model a chance to relax and get acquainted, and it allows me a chance to study the model's natural poses.

Artist Bob Ragland invited me to draw at his studio one day when he had hired some mimes to model. None of my drawings was complete enough to become a painted image, but this particular gesture stayed in my mind for years. Then at a street fair I saw a juggler and realized that if I turned my mime into a juggler tossing balls into the air, the image would be complete.

The process of developing a painting does not always take years, but it often is quite demanding. So it is important to choose subjects that are interesting to you, like this drawing of the mime. Then you will be happy to keep coming back to it until it is a completed painting.

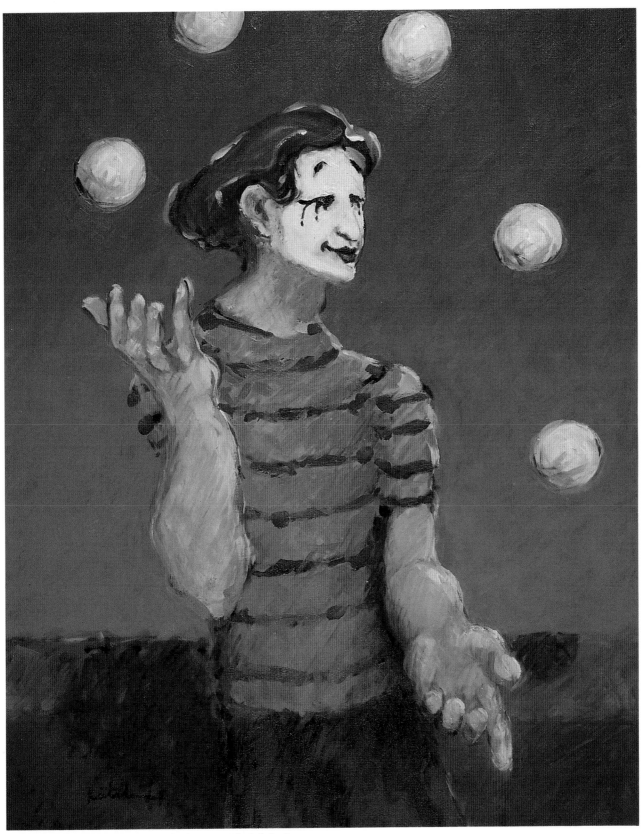

THE JUGGLER, *30" × 24" (76 × 61 cm), oil, courtesy Saks Galleries, Denver*

Lighting the Subject

A final element to be considered in your setup is lighting. The way you add light and create shadows affects every other aspect of your setup.

Well-planned lighting establishes the volume of your objects; it helps develop an overall mood and enhances the total design. A scene or object can become an intriguing subject just because of the way it is lit. I once drew a dancer leaping in the air during a rehearsal. I liked the shape of the body, but that alone was not enough to create a total painting. Then, remembering the art of Edouard Vuillard, I got the idea of using backlighting to add a sense of drama to the composition. I used the windows behind the dancer as my sole source of light so that the background was light and the figure was dark, almost a silhouette. This reversal of lighting (usually the figure is in the spotlight) made *Ronnie in the Air* (page 31) a much more exciting image.

Another painting that was made with lighting was *The Croquet Party* (page 33). This was a simple, romantic scene of costumed figures on the lawn until I added the drama of late afternoon shadows. The strong graphic pattern of shadows

falling across the grass made the image much more powerful.

It is not always necessary to use a very obvious light source. Sometimes soft, diffused lighting with no obvious shadows is most effective.

Whatever kind of lighting you set up, it should be consistent throughout the painting. If you have strong shadows in one part of the image, there should be strong shadows throughout. If the shadows are cast toward the left in one part of the piece (as if a light is shining from the right), the direction of shadows should be the same·in other areas as well.

To get a sense of how lighting will affect your image, set up all the elements you plan to paint. Then black out all the lights in your studio except for one lamp. Move that lamp closer to the subject and then farther away. Move it to the right and to the left, all the while noticing how the light source changes the look of the setup.

Next add a second light source. What happens when lights are shining from two different directions? From three directions? Finally add bright overhead lights. How does this change the image?

Suggested Project

Lighting a Setup

Create a simple setup in your studio using a small arrangement of fruits, vegetables, or other objects. Choose a subject that won't wilt, fade, or shrivel up while you are working.

Place one strong light to the right of your setup. The light should be bright enough to create strong cast shadows. In the medium of your choice, create a detailed study of the scene. Next, without changing anything else, move the light from the right to the left. In the same medium, complete another study.

When you are done, place your two studies side by side and see how much the lighting affects the piece, especially how shadows change the composition. If you want to take this exercise a step further, paint the same scene with the lamp in still other positions—higher, lower, farther away, closer.

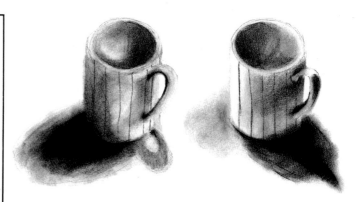

These two drawings show what happens to an object that we are setting up when we change the direction of the light source. In the drawing at left, the light, a single lamp, is shining from the right in the rear. Notice that the shadow inside the mug is on the right, the shadow outside the mug on the left, and the heavy cast shadow forward and to the left.

In the drawing at right, the lamp has been moved to the left rear. Changing the position of the light source reverses the positions of the shadows. Look at how the shapes of all the shadows also have changed. This is most apparent in the shadows on the handle and the totally different forms of the cast shadows.

APPLES AND PEARS,
11" × 14" (28 × 36 cm),
watercolor, collection Kathryn Post

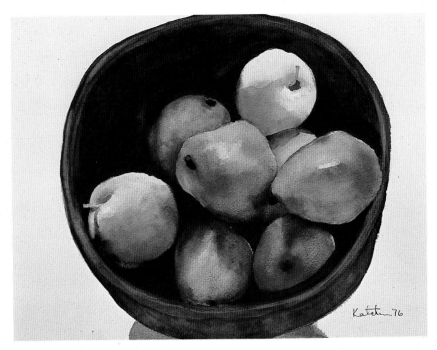

This subject was just another bowl of fruit until I stood up and looked at it from above. From that viewpoint the very dark shadows caused by the overhead lighting provided a dramatic counterpoint to the rich colors of the apples and pears. In arranging your subject and lighting, it is valuable to assess the image from many distances and directions.

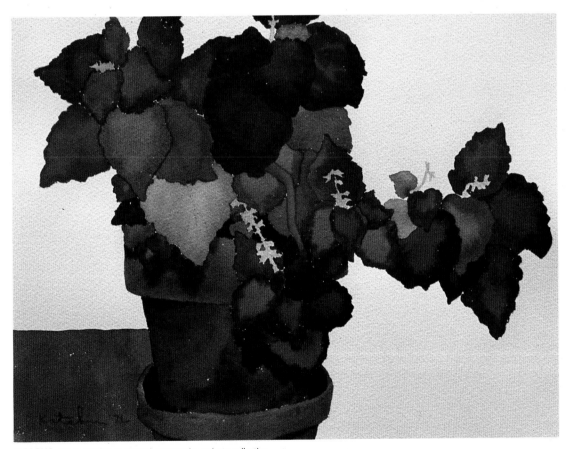

COLEUS, *11" × 14" (28 × 36 cm), watercolor, private collection*

In some cases the subject of a painting needs strong background elements to enhance the total image. Other subjects, like this coleus plant, have such interesting shapes and colors that an elaborate background would detract from them. Here I set the plant on the edge of a table and used diffused lighting to create a simple but dramatic division of the negative space.

I started my painting Oranges *by studying the subject. Even when painting such everyday subjects as oranges, it is helpful to study them first—their shape, color, and texture, how they reflect light, what shadows they cast.*

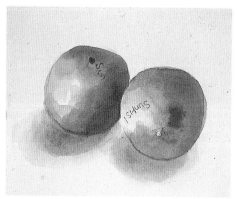

ORANGE STUDIES, *9″ × 12″ (23 × 30 cm), watercolor*

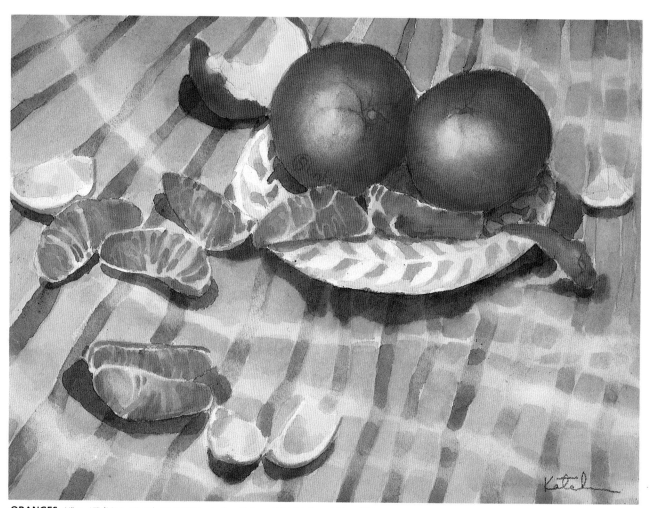

ORANGES, *11″ × 15″ (28 × 38 cm), watercolor, courtesy Gallery of the Southwest, Taos, NM*

I knew that I wanted to paint the two oranges I had been studying, but I wasn't sure what else I wanted to put into the composition. Most of my still lifes were fairly simple, so I decided to try something more complex. To the whole oranges I added orange segments, pieces of peel, and lemon wedges, a wonderful assortment of small shapes to make up my main subject. Once I had decided on the main subject, I was able to add supporting elements like the dish and cloth to complete the image. A strong light from above creates the bright highlights on the whole oranges and the dark cast shadows.

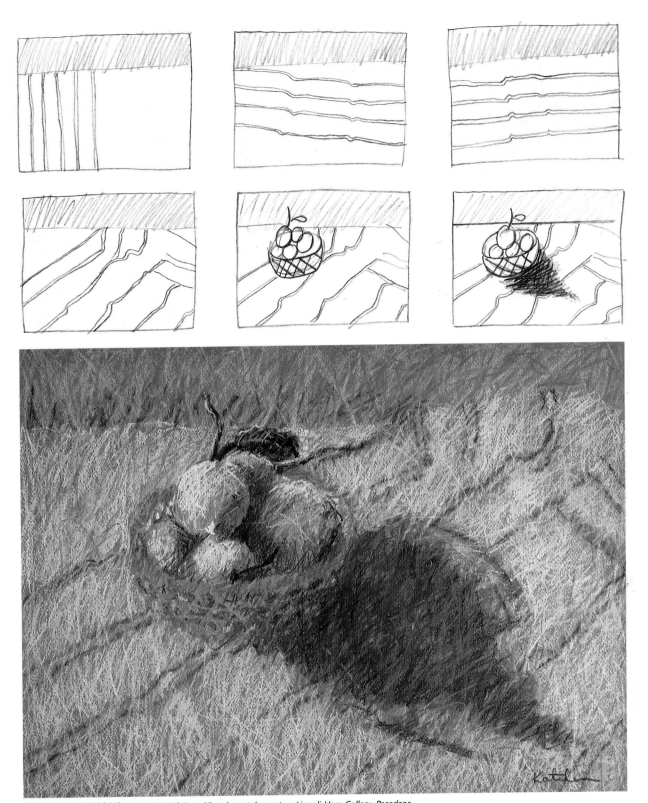

BASKET OF LEMONS, *19″ × 25½″ (48 × 65 cm), pastel, courtesy Lizardi-Harp Gallery, Pasadena*

The subject for this still life was one that I arranged in my studio, carefully placing each element to make the strongest possible design. In the studies above, you can see how I tried various placements of the dish towel before I found the one I liked best. Because of the stripes, the towel was a very important design element.

When I placed the basket back on the table, I had to find the spot that would work best with the design of the stripes. Finally I added a strong cast shadow to fill some of the big empty space on the right of the image. Cast shadows often can be used to add a needed design element without making the composition seem too cluttered.

STILL LIFE WITH LEMON BLOSSOMS, *27½″ × 29″ (70 × 99 cm), pastel, courtesy Lizardi-Harp Gallery, Pasadena*

In setting up this painting, I arranged several objects on a tabletop. The shapes themselves were interesting and made a well-balanced pattern, but the total image lacked drama. Then I shone a strong light from the upper edge. The resulting highlights and shadows turned the subject into a much more exciting scene.

In the top diagram, you can see how the objects form a balanced pattern, but not very exciting. The bottom diagram shows how strong lighting makes the value contrast much more dramatic, enhancing the entire composition.

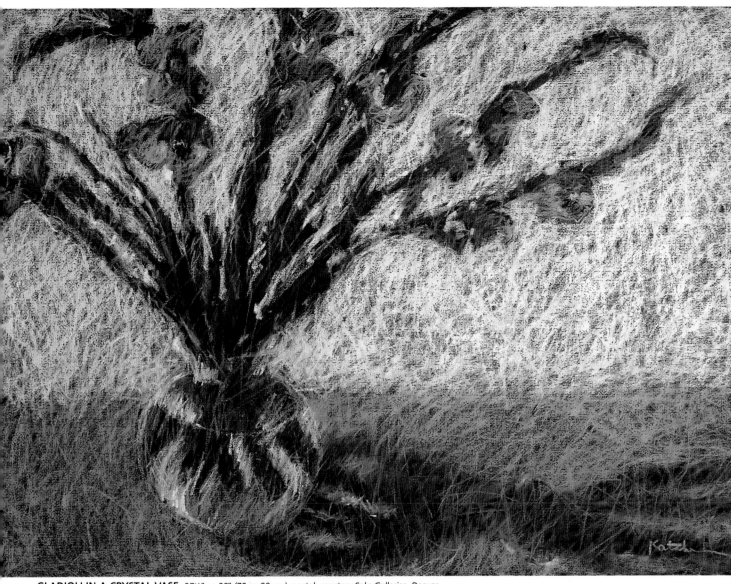

GLADIOLI IN A CRYSTAL VASE, *27½" × 39" (70 × 99 cm), pastel, courtesy Saks Galleries, Denver*

Notice the totally abstract shape of the flowers in this painting. This shape was the key to the design of the whole painting. See how the spaces between the flowers provide an interesting pattern in the negative space. With strong side lighting, this shape is doubly important because it also determines the shape of the cast shadow.

By blacking in the negative space, we can see how the basic shape of the vase of the flowers and its cast shadow divides up the composition.

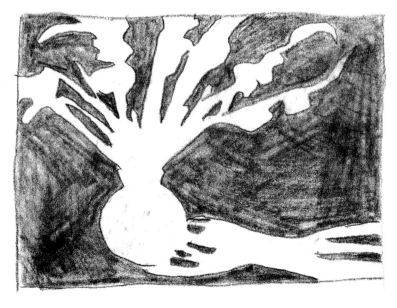

Working Outside the Studio

Up to now I have been talking about setting up your subject in the studio. Sometimes that is impossible. How do you set up your subject when you are working on location? You can't move a tree around the way you can move a couple of oranges. You can't change the direction of the sun the way you can move a spotlight.

One solution is to look for images that are complete as they are. There are many views in nature that seem to be composed just for a painting. You can find them by looking at the abstract elements of the scenes around you.

When the scene is not perfect as is, you can sketch the image as it is and then manipulate it in your sketches. One advantage the artist has is the option of altering the pieces. If a tree doesn't fit, eliminate it. If a dress is the wrong color, change the color.

In many ways setting up a painting is like working a jigsaw puzzle; you must put the pieces together in such a way that they make a total image.

For a painting, you start with a simple idea and then, piece by piece, add all the elements needed to complete a total image. Once you see this image in your mind, you are ready to turn it into a painting.

STUDY OF RON, *11" × 14" (28 × 36 cm), watercolor, collection Ronald Sanchez*

I painted this watercolor study of my friend Ron during lunch one day. There were many things I liked in the sketch, but I didn't think it was enough by itself to warrant a larger painting.

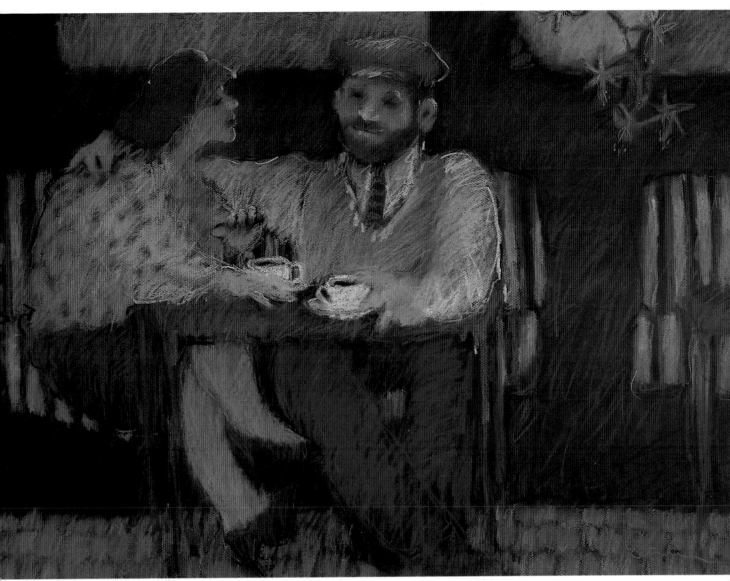

LOVERS IN A STRIPED BOOTH, *27½" × 39" (70 × 99 cm), pastel, courtesy Saks Galleries, Denver*

Some months later I saw and sketched a woman drinking espresso in a cafe. I remembered the watercolor of Ron and thought this additional figure might be what I needed to complete the image.

Since we cannot always set up paintings in the studio, we must learn to record separate elements of paintings and then to work from combinations of those sketches. This painting is an example of that process. I drew the figures separately—several months and several miles apart. Because of their compatible positions and appearance, I was able to combine them as if they were an actual couple. For the background I took elements from the watercolor study of Ron, but rearranged them to fit the new composition.

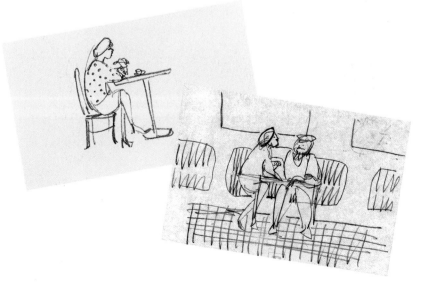

47

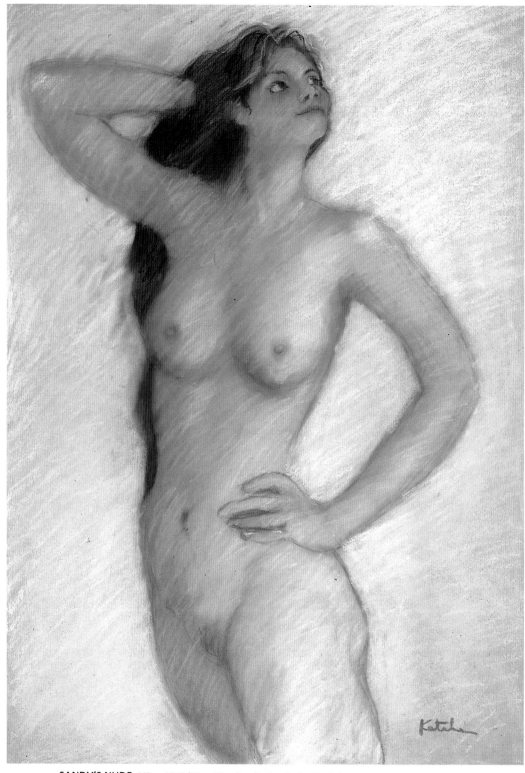

SANDY'S NUDE, *39″ × 27½″ (99 × 70 cm), collection Sanford D. Kaiser*

This painting shows how much just the pose can determine the mood and focus of a figure painting. The pose is graceful, but stable; the intent is to show a relaxed, sensual woman who is standing comfortably.

SUNBATHING ON MISSION BEACH,
11" × 14" (28 × 36 cm), watercolor

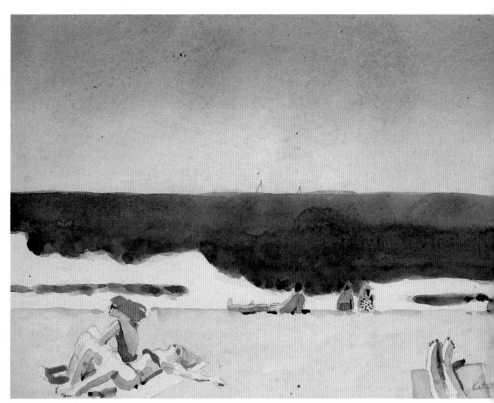

Developing an image outside the studio can be especially difficult when you are working with a group of moving people. I generally start with a sketch for locating the basic shapes. After I have organized my composition in the preliminary drawing, I am able to start a more elaborate study like this watercolor, filling in each shape as I had placed it in the sketch.

First I located the main landmarks of the background—horizon lines for the ocean and sand, and lines for the surf. Then I began to place the figures, thinking about each one's shape, size, and location. The primary figures were the women sunbathing at lower left. Next came the man reclining in the center and then the partial figures behind the sand dune. Finally I added the feet because I felt the composition needed something for balance in the lower right.

Suggested Project
Drawing a Group

Take your sketching materials to a place where there are a lot of people in a relaxed environment. Cafes are good locations, also parks, malls, and beaches. What you are looking for is a selection of people who will be sitting or lying in one place for a time. Locate yourself in a comfortable, unobtrusive spot where you have a good view of the activity.

Start by making a small thumbnail sketch of the scene. Locate all the major landmarks. In a cafe, mark the tables and chairs and other large objects; in a beach scene mark the horizon line and water line.

Within this loose drawing, place an appropriate shape where the largest, most important figure will be. Then fill the composition with shapes for the minor figures. These can be loose, general shapes; you are using them just to develop the composition. When you have organized all the shapes in your thumbnail sketch, you can begin a more formal study.

Again begin by locating major landmarks in the setting. Then draw one figure that you see as your major figure. Add more figures to the sketch one at a time until you have filled in the total composition as you planned it in the thumbnail drawing. Then refine the figures and the background. Add details last.

Developing a Scene with Figures

Where do ideas come from? Ideas for paintings come from looking at the world, observing what is around you. Objects, people, colors, shapes—anything you see can inspire a painting. This piece was suggested by the spectacle of a ballet concert.

I love attending concerts; the audience entertains me as much as the performers do. Here I decided to paint the total spectacle of a dance concert, dividing the attention between the stage and the audience. In looking at a scene or any other subject, it is important to see the elements as abstract visual elements. For instance, I looked at the people here as shapes, to be fitted together with the chairs, stage, backdrop, and other objects to make one total design.

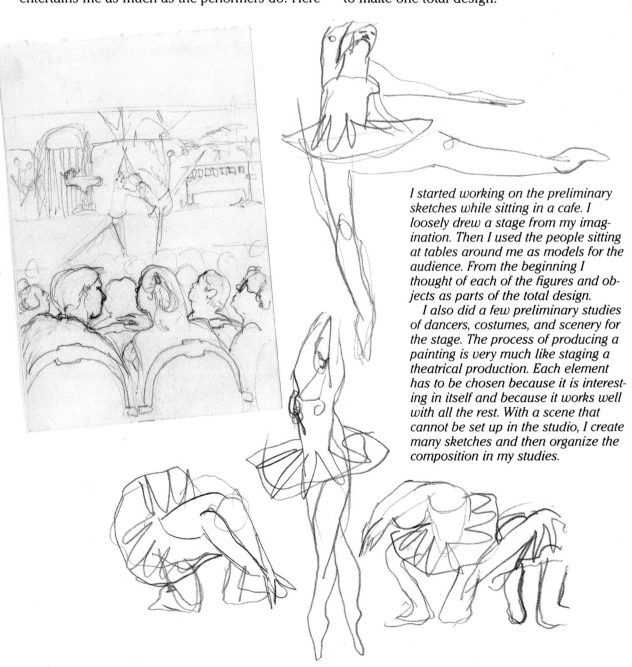

I started working on the preliminary sketches while sitting in a cafe. I loosely drew a stage from my imagination. Then I used the people sitting at tables around me as models for the audience. From the beginning I thought of each of the figures and objects as parts of the total design.

I also did a few preliminary studies of dancers, costumes, and scenery for the stage. The process of producing a painting is very much like staging a theatrical production. Each element has to be chosen because it is interesting in itself and because it works well with all the rest. With a scene that cannot be set up in the studio, I create many sketches and then organize the composition in my studies.

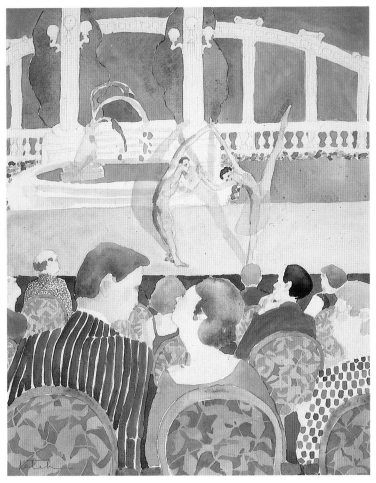

This is one of the color studies I completed in preparation for the painting. There were some elements in the study that pleased me—the placement and gesture of the audience, the texture of the chairs—but the total piece seemed to be split into two separate paintings. I decided that the colors and the textures of the stage had to be more similar to the audience.

I made the composition square to spread out the audience and allow room for a more intricate pattern in the upper half of the composition. I decided to add hats to the women in the audience to create an element of fun. Also I thought that making the audience more "costumed" would relate them more to the stage.

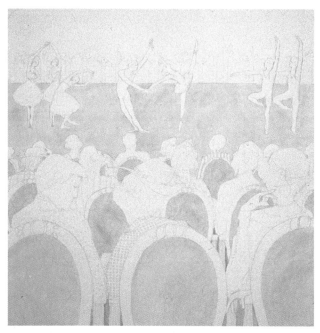

Step 1. I started with a basic pencil drawing. Then with a light purple wash I began to mark where the darker areas would be. I like to control value from the beginning of a painting, especially with watercolor, which allows so few changes later.

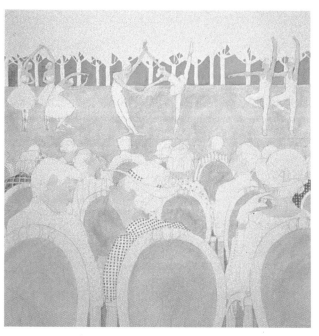

Step 2. I painted the skin areas with a very diluted warm brown, adding some touches of red into the wet brown for cheek color. I added aqua for textural patterns. Notice how I balanced the aqua throughout the composition.

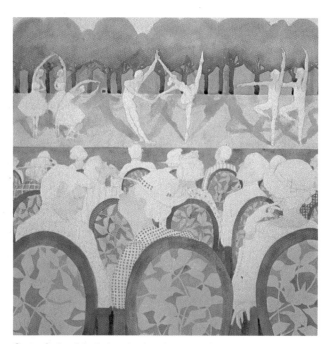

Step 3. I added the darker brown of the chairs and the green of the trees. Notice how the shadow of the dancers add to the pattern, corresponding to the intricate pattern in the chairs.

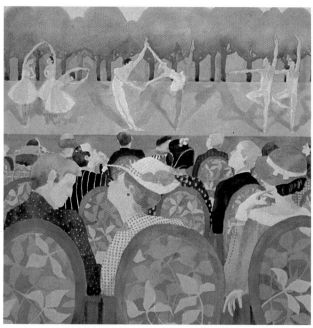

Step 4. With the colors added to the clothes, all the basic shapes of color were established. Notice how the same few colors were used over and over; my palette consisted only of purple, aqua, brown, and pink, with yellow and red for minor accents. It is possible to create the impression of a multitude of colors with only a few, and using a limited palette makes it easier to maintain color harmony.

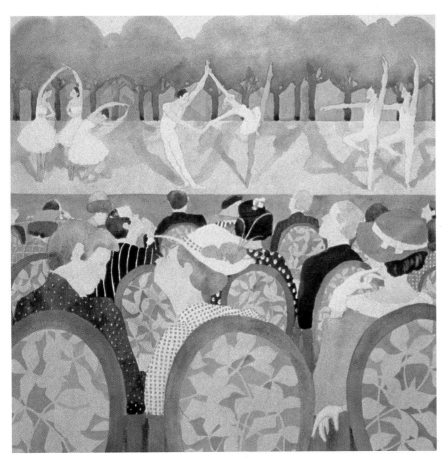

Step 5. *Here I began to use aqua to establish volume, using that color for shadowed areas within the figures. I also added aqua to the patterns of the chairs.*

Step 6. *By layering washes of brown and purple I was able to create the darkest values in the painting. I added some opaque white highlights to the figures for maximum value contrast. At this point I thought the painting might be done, so I set it aside for a while.*

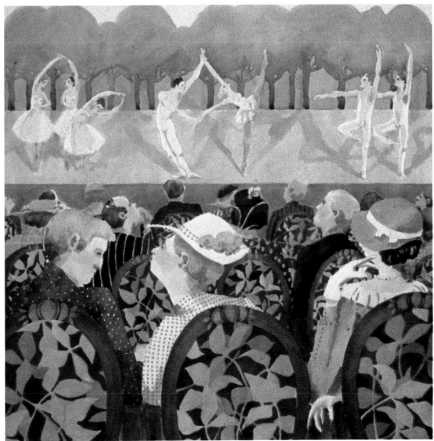

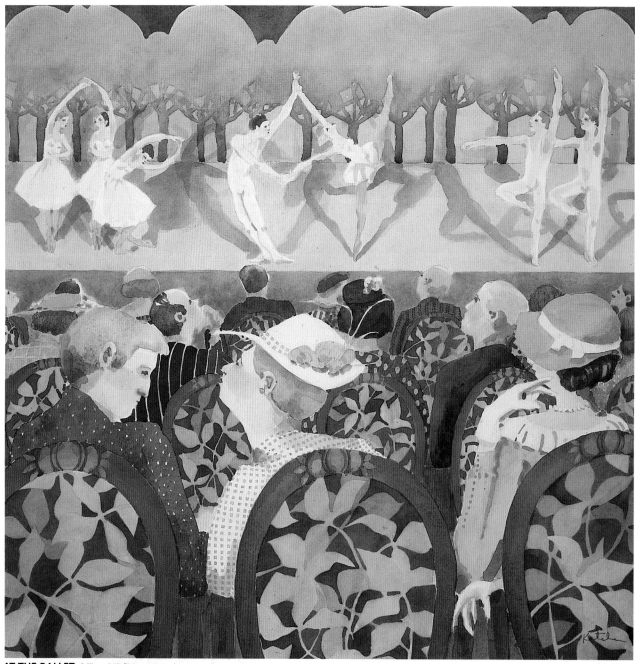

AT THE BALLET, *30″ × 30″ (76 × 76 cm), watercolor, courtesy Lizardi-Harp Gallery, Pasadena*

Finished painting. *Looking at the painting again after some time had passed, I realized that the top didn't have as much visual weight as the bottom. I added some purple above the trees, darkened the shadows on the stage, and intensified the pattern of the branches in the trees. The final touch was softening the opaque white highlights.*

Demonstration

Designing with Light and Shadows

I arranged a pitcher and two apples on a simple tabletop in my studio as setup for a very simple still life. Then I noticed the interesting shadows on the wall and decided to include them in the composition. Their shape is as important to the design of the painting as the objects in the original setup.

In this photograph you can see how I arrange a setup of objects. I almost never paint from photographs, preferring the challenge of converting a three-dimensional subject to a two-dimensional image.

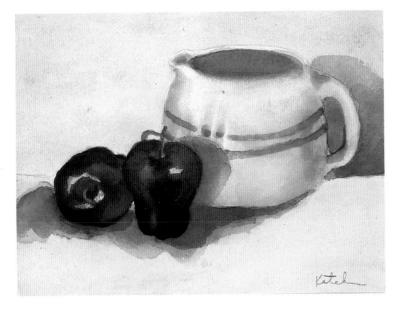

I painted this study in watercolor before I decided to add the shadows. I was concerned primarily with color, seeing how a variety of reds and blues would work together. Also I had added a lamp on the right that cast strong shadows to the left.

In this sketch I worked on combining the basic still life with the interesting pattern on the wall. I went back to the original light from the window and drew the objects large and in the center. I changed this later so that the wall shadows would become a more important part of the composition.

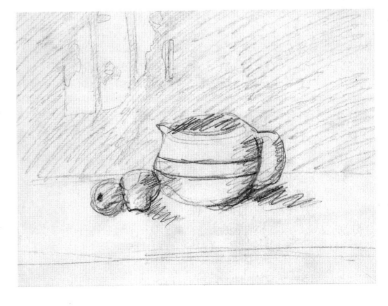

Step 1. In the basic drawing you can see how I changed the composition, making the pitcher and apples smaller, moving them down and to the right, and making the wall pattern more prominent.

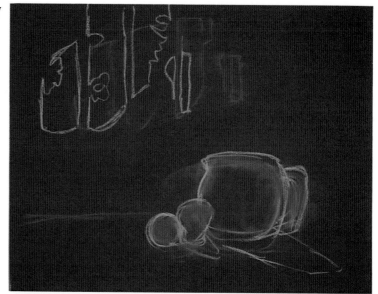

Step 2. Here I blocked in the main value shapes with my four basic colors: burgundy for the darkest shapes, light violet and light green for the middle values, and a very light ochre for the brightest highlights. I rarely use pure white or black.

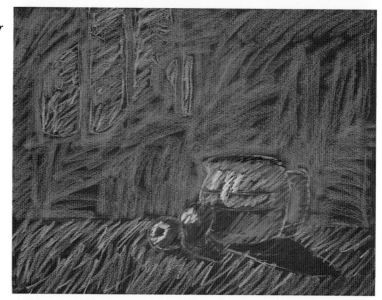

Step 3. Next I began to solidify my values. With a loose, energetic stroke I added a lighter green and lavender to my lights and a darker violet to my darks.

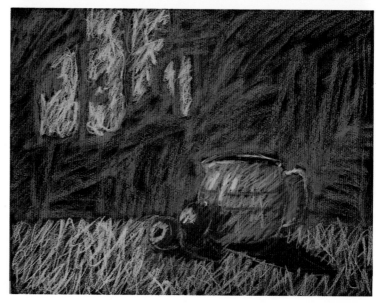

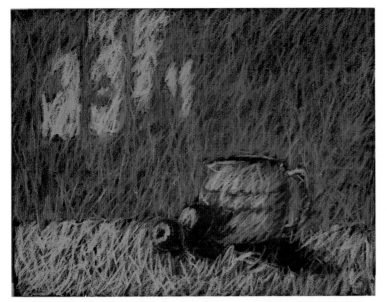

Step 4. *Here I began to add more colors to the painting. I picked out the blue-green from my color study and used that in the background. I wanted strong color in the background because that is such an important part of the piece. Then I added red for the apples. I also put red in the shadows.*

Finished painting. *I brought down the value of the background with lighter pastels. In order to keep a strong pattern on the wall, I used contrast in color temperature, adding warm yellows to the highlights to contrast against the cool blue and violet in the rest of the wall. I added more yellow in the tabletop, the fruit, and the pitcher to help balance the color in the total painting. With darker colors I defined the shapes of the objects and intensified all the shadows.*

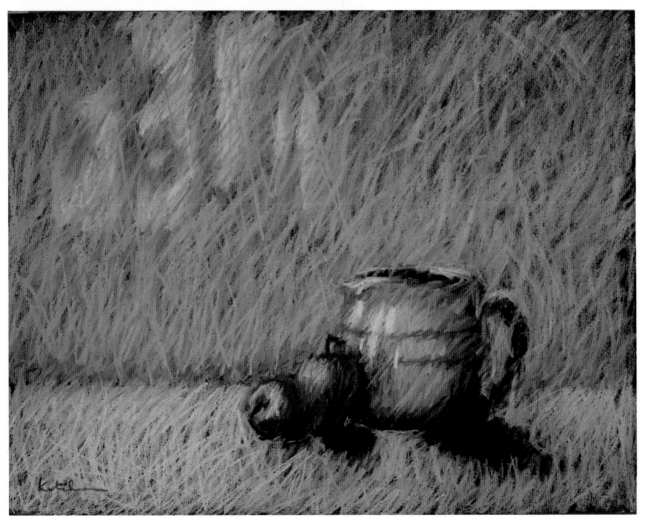

WALL SHADOWS, *19" × 25" (48 × 64 cm), pastel*

Building the Composition

Too many artists think that composition is something that just happens. As a result, many good paintings fall short of being great paintings because the basic design is faulty. Perhaps viewers are unable to articulate what is wrong with a painting, but if there is a flaw in the composition, they will feel it.

There are two compositional elements that make a painting work: balance and movement. I like to think of composition as an assemblage of shapes for balance and movement. As we have seen, planning the shapes and then putting them together is something like a working puzzle. There may be more than one way to arrange the pieces, but if you don't fit all of them together, you will always have the sense that something is wrong.

Balance in a painting is the same as balance in anything else—evenly distributed weight. In a well-balanced composition you should be able to draw a line dividing it in half and find just as much to interest the eye in both halves. You should be able to divide the composition diagonally, horizontally, or vertically and still feel the balance of both halves. The most extreme kind of balance is symmetry, where one side is an exact mirror image of the other.

The other element, movement, is the pull of your eye across and around the piece. If there is movement in a composition, you will be drawn into it. You will look at one shape and then your eye will be led to another and another. If there is no movement, your eye will register the whole painting or one part of the painting and go no further.

In the best compositions both of these elements work together. There is a comfortable sense of balance, but it is not static; the eye moves easily throughout the piece.

Balance is fairly easy to achieve. Thinking of a composition as an arrangement of shapes, I make sure that for every shape I place in one side of a painting, I also place a shape in the opposing side. I keep in mind all four ways of dividing the format.

Adding Movement

In order to give life to my compositions, I try to temper balance with movement. Some of the techniques I use are variety of shape, value, or color; focal point; directional lines and shapes; and closure.

As the simplest of examples, think of a composition with only two shapes. If both are square and placed symmetrically, the picture is static, but if one shape is a square and the other is a circle, the piece has much more interest. Your eye will move back and forth between the circle and the square.

Size can work in the same way. If we put one big shape across from two small shapes, again we have balance without symmetry. What happens if we put a big shape across from a small shape? We

This composition shows both balance and movement. By placing the figure near the center of the canvas, I start out with balance. Another element of balance is the repeated rectangles at the top set against the diagonal pattern at the bottom.

Movement is provided by the angle of the figure and the rhythmic flowing lines of the hair and dress. It is enhanced by the diagonals through the painting. Look at the line from upper left to lower right—through the figure's right elbow and breast down to her left foot. Now notice the strong diagonal thrust in the opposite direction caused by the cast shadows.

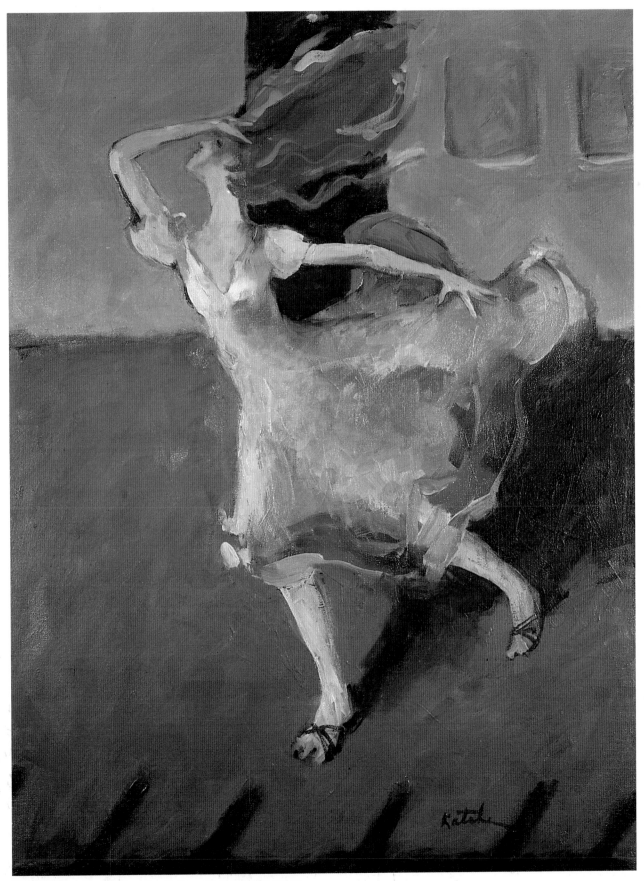

TAOS WIND, *24" × 18" (61 × 46 cm), oil, courtesy Saks Gallery, Denver*

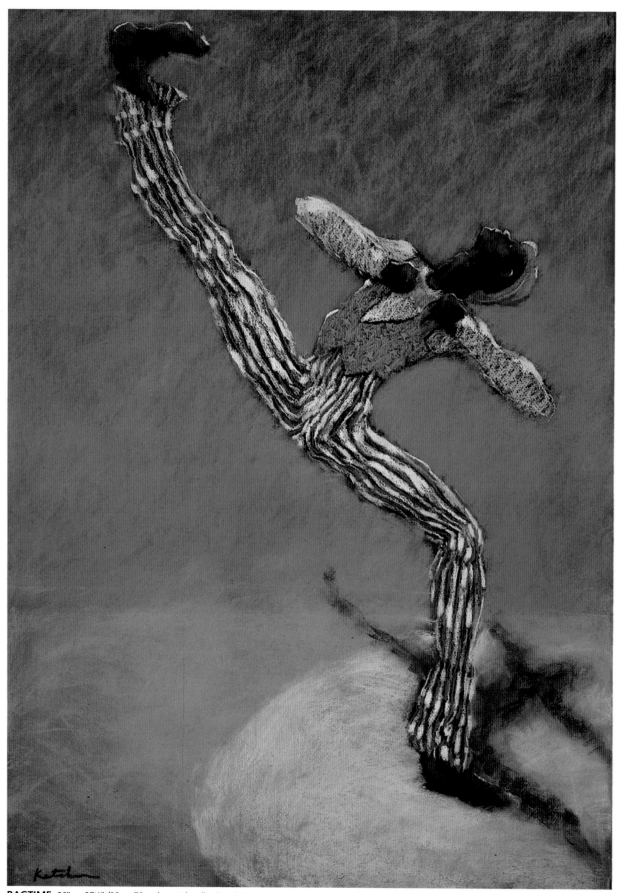

RAGTIME, *39" × 27½" (99 × 70 cm), pastel, collection Gary Antonoff*

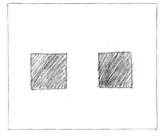 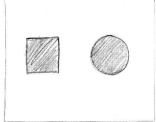 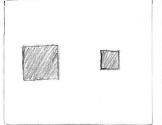 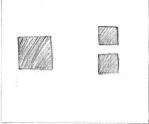

At left we have a symmetrical composition. It is certainly balanced, but it is also static. If we change one of the squares to a circle, we still have balance, but we have movement as well. Notice how the eye moves back and forth from one shape to the other.

If we put a large shape across from a small shape, we no longer have balance. The side with the larger shape feels heavier, as if it were falling or sinking. This creates tension and can be used effectively within a painting. We can restore balance simply by adding another small shape to the right side.

no longer have total balance. Now we have tension. The composition is not completely unbalanced—we do have opposing shapes—but it is an uncomfortable balance.

Tension can be a successful element in a composition if it is used well; it keeps the viewer from feeling too comfortable or complacent. Tension creates a sense that something is about to happen, and so the viewer keeps looking at the piece. I try to include some elements of tension in every composition, not so much that the piece looks unbalanced, but enough to keep the viewer interested.

Focal point can also be used to create movement. The focal point is the shape of foremost interest in the composition. In some pictures it is a result of the subject. In a portrait, for example, the figure's face is the logical point of interest. That is the area the viewer's eye is immediately drawn to.

Even in a portrait, however, the most obvious shape need not be the focal point. By manipulating size, contrast, draftsmanship, or color, you can turn any section of the painting into the focal point. Paul Pletka, a southwestern artist, makes the hands of his Indians more important by drawing them much larger in scale than the faces.

An obvious focal point in a painting gives the viewer's eye a place to begin. Then something is needed to draw the eye away from that spot. One way to create a movement is to add a secondary focal point, a lesser object or shape in another part of the composition.

Sometimes focal points are not objects, but areas of extreme contrast. If most of a painting is blue but there is one small shape of orange, that shape will become a focal point. If the whole piece is dark except for one very bright spot, that light area will attract the eye.

Another way to move the eye away from a focal point is with directional lines and shapes. For instance, if you draw a line through the focal point, the eye will follow the line to another part of the painting. Suppose you draw a tree in an empty ground. The tree is the focal point and the eye rests there. If you add a horizon line, either above or below the tree, the eye still remains on the tree. However, if you draw the line through the tree, the eye automatically follows it.

Shapes themselves can create movement. Square or circular shapes simply sit on one spot and hold the eye there. On the other hand, a triangle or other pointed shape leads the eye to wherever the shape is pointing.

Closure is a psychological term that describes the mind's process of completing an incomplete shape. If you put an incomplete circle into a painting, the viewer's eye will complete it. The same will happen if you suggest a shape. For instance, if you paint in three unconnected objects, the eye will fill in the lines to make them a triangle.

I don't use every one of these devices in every painting. Sometimes I paint a subject that is simple and peaceful; then I want more balance. Sometimes I choose a subject with a lot of activity; then I want more movement. The composition should always suit the subject, using both balance and movement.

This painting is an excellent example of the effective use of tension within a composition. Because all the weight and activity are in one diagonal half, we feel uncomfortable, as if something were about to happen. That feeling is what the piece needs to make the viewer understand that the dancer is in motion. He is not going to hold that pose for long; he must move. The tension in the composition is what makes the viewer look at the painting, waiting to see the dancer move.

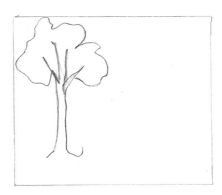

In this drawing the tree is the obvious focal point. The eye goes immediately to the tree and stays there.

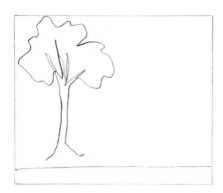

If I draw a horizon line below the three, the eye registers the line but still stays on the tree.

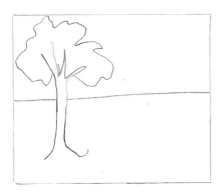

If I draw a line through the focal point, the eye still goes first to the tree, but then it follows the line. We automatically look to see where the line leads. This simple line, correctly placed, adds movement to the composition.

Composing from One Shape

There are many ways to develop a composition, but I usually start with one main shape. It might or might not be the focal point, but it is the foundation piece that locates all of the other shapes. I always try to make every shape as interesting as possible. For the first shape this is especially important because it is the basis on which everything else will be built.

Rarely do I begin in the exact center; that would start me off with a static composition. So I place the shape off-center, but where? Usually the shape itself will give me a clue to its placement.

If it is a directional shape, one that is pointing, I place it so that it is not pointing off the page. That is, if the shape is pointing to the top of the painting, I will usually place it more toward the bottom. That way it directs the eye toward the rest of the painting.

The same principle holds true with the direction a figure is facing. If a figure is looking off to the right, the viewer will look off to the right, so I will usually place that figure on the left side of the composition. If the figure is a solid shape, I usually want to give it some space at the bottom to rest on. I don't put it too near the top, however, where it might appear to be floating.

Also I want to keep in mind what other shapes I will add to the composition and how they should relate to one another. If my main shape is a flower, for instance, I also want to leave space for the shapes of the stem and leaves, the vase, and other parts.

One additional thought about the main shape: it need not be just one object. I might consider a flower, stem, and vase all one shape. Or, if I am painting several pieces of fruit, I might consider a cluster of three apples or persimmons as one shape.

Filling in the Composition

After I have placed the main shape, I stand back and look at the composition. Sometimes it is complete at that point. If the major shape is a large, interesting form, it might be enough in itself with the shape of the negative space to give the composition balance. Remember that negative space is not necessarily empty space. The shape around or outside your main form is also a shape to be considered. In your composition, background is just as important as foreground.

Every composition works differently because every composition is made of different shapes, but the process is basically the same. First I place the main shape and then I arrange the additional shapes for optimum balance and movement.

As I add more shapes to the composition, where do I put them? I go back to my basic considerations of balance and movement. Since I have probably put my main shape off-center, I will probably want a balancing shape in the opposing half of the format.

In order to check your composition, look at the piece in terms of abstract shapes. How do those pure forms work together? Then turn the composition on its side and upside down. Look at it in a mirror. The shapes should provide balance and movement from any direction.

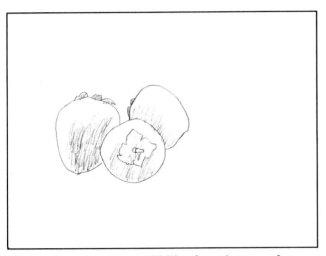

Here I am composing a still life of persimmons. I start with a cluster of three pieces of fruit and put this shape to the left of the center.

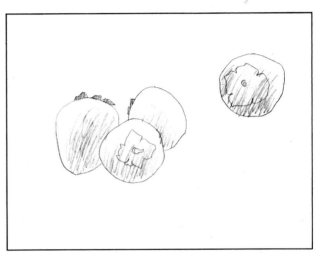

Now I need something on the right for balance, so I place a single persimmon in the right half.

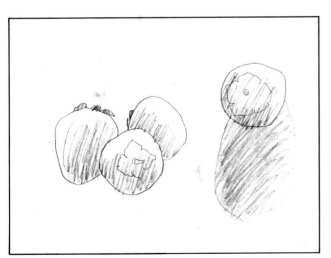

The one piece of fruit is not heavy enough to balance the group of three, so I strengthen it with a heavy cast shadow.

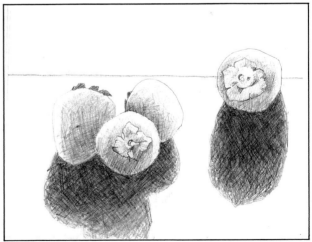

To keep the lighting consistent, I have to add shadows to the other pieces of fruit. Then to give the top more weight and movement, I draw a horizon line through the upper persimmon.

The triangle is a shape that creates movement within a composition. The eye naturally looks in the direction that the triangle is pointing.

Closure is the tendency of the eye or mind to finish incomplete shapes. When we look at the three separate squares, we see them as the points of a triangle and our mind fills in the edges. This is another way to add visual interest to a composition.

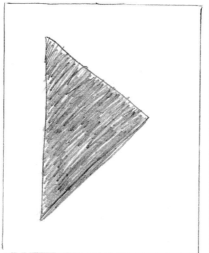 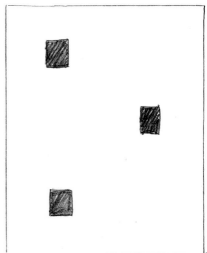

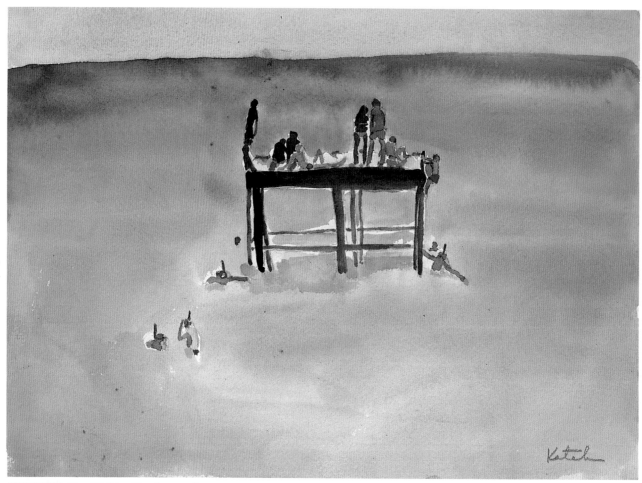

SWIMMERS, 9″ × 12″ (23 × 30 cm), watercolor

A swimming platform in the ocean near Cancun, Mexico, was the first shape I used in developing this composition, which is fairly simple and static—one large, squarish shape near the center of the piece. It is offset somewhat by the figures at lower left, but they are not large enough to add much weight. Also, the horizon line just sits above the focal point; it would be more powerful compositionally if it intersected the main shape.

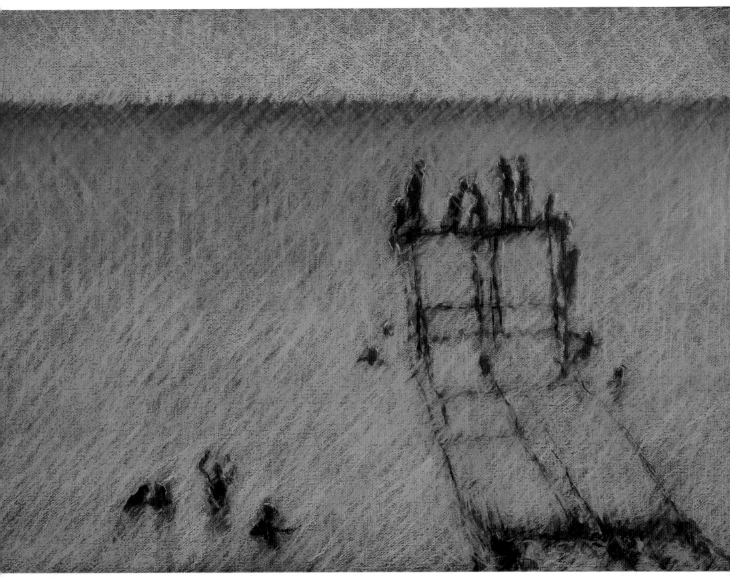

SWIMMERS, *27½" × 39" (70 × 99 cm), pastel*

In order to add excitement to the composition, I first moved the main shape to the right, away from the center. Next I added diagonal lines down to the lower right corner and anchored them with a strong shadow. I completed the triangle by placing a cluster of dark figures to the lower left. I left the horizon line to balance all the activity at the bottom.

Demonstration

Creating Movement with Directional Lines

In this painting the eye naturally follows the curving lines of the path and bench. Visual interest and balance are provided by the lively intersecting lines of the shadows.

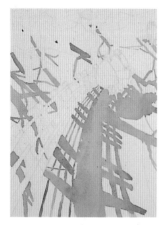 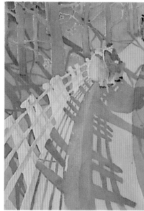

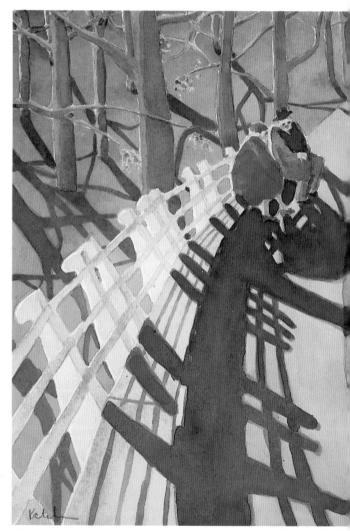

Step 1. *Unlike most of my compositions, which are simple arrangements of a few large shapes, this was planned to be like a jigsaw puzzle of many small pieces. I began to develop the pattern by blocking in the shadows.*

Step 2. *Gradually I filled in all the other base colors— dappled yellow and green for the autumn lawn, blue for the benches and clothing, brown for everything else. I built the painting slowly with successive washes of light color. I used only a few colors so that color repetition would help unify the complex design.*

Finished painting. *In the final piece you can see that the intricate shadows, especially the dark shadows of the foreground, are the center of interest. The two larger figures are also a focal point, but secondary to the shadows. The whole painting has become a tapestry of pattern, balanced because the whole painting is divided into small segments. Movement is provided by the light shape of the bench and path.*

SUNDAY IN CENTRAL PARK, *14" × 11" (36 × 28 cm), watercolor, courtesy Gallery of the Southwest, Taos, NM*

The negative space in a painting should never be ignored or taken for granted. It is as significant in developing a composition as the subject itself. Because of the white background, you might think of this painting as being just the colored areas; however, the white areas are also important to the total composition. In the diagram you can see the interesting pattern that is created by blackening the negative space. An artist who composes well considers both the subject and the negative space.

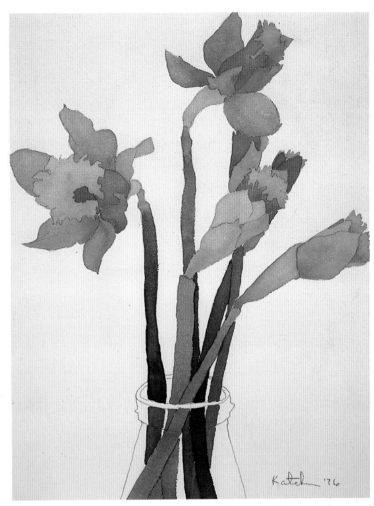

ENGLISH DAFFODILS, *14" × 11" (36 × 28 cm), watercolor, collection of the artist*

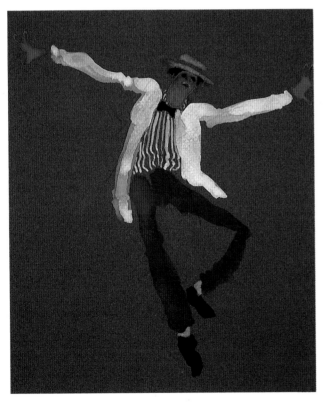

When creating a composition with a human figure, I like to use the body to design the most interesting shape possible. Dancers allow for wonderful divisions of space, and in this painting the lines of the figure not only create movement but divide the negative space into interesting shapes as well.

THE ENTERTAINER, *10" × 8" (25 × 20 cm), watercolor on blue paper, collection Martin Brotherton*

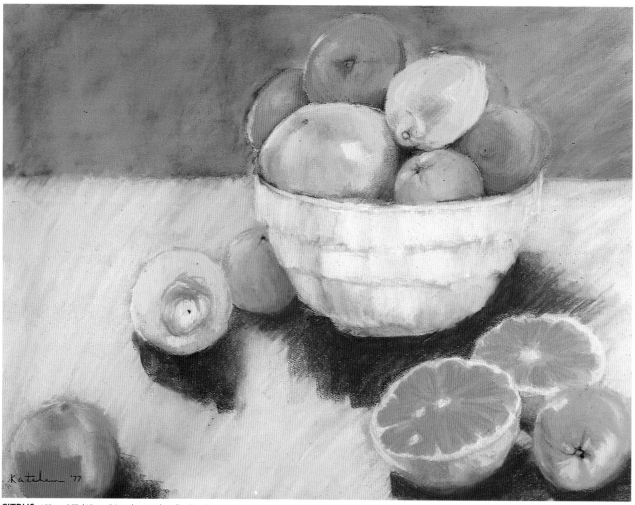

CITRUS, *19" × 25" (48 × 64 cm), pastel, collection B. Ann Levin*

Suggested Project
Analyzing a Composition

Select a reproduction of a painting with a well-defined subject and negative space.

Cover the picture with tracing paper. On the tracing paper draw an outline of all the main shapes in the painting. Shade in the shapes of the subject with a dark value. Leave the negative space white except for cast shadows and major background objects. Make those gray.

Remove the tracing paper and look at the arrangement of abstract shapes that you have drawn. Do they make an interesting design? Do all the dark shapes fall in only one section of the composition or are they balanced? Are they placed in such a way that they make your eye move through the total format? What about the gray shapes?

Now hold a string across the traced composition so that it is divided in half horizontally. Do the dark shapes fall evenly in both halves?

Move the string to divide the piece vertically. Again, analyze the balance of the painting. Repeat the process with the division diagonally.

To see the composition of any painting, you must reduce it to abstract shapes. When you are planning your art, you can apply the same principles.

In the painting on page 68, several small pieces of fruit actually fit together to form a few large shapes. By blackening these shapes, we can analyze the composition. Notice how the dark shapes create a triangle from the lower corners to the upper center. We can also check the balance of the painting. When we dissect the composition vertically, there is a bit more weight on the right, but not enough to cause excessive tension. Divided in any other direction, both halves carry equal weight.

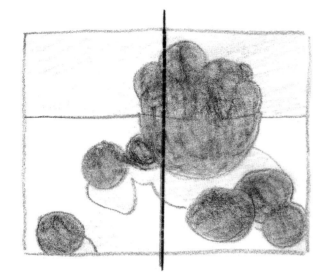

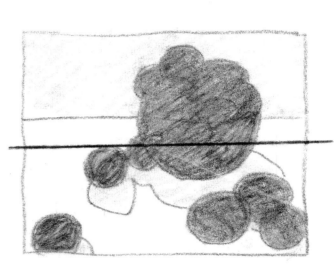

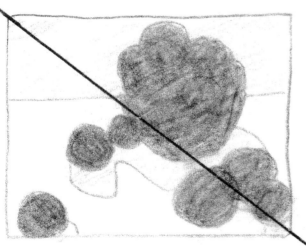

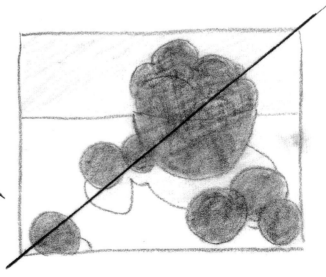

Demonstration
Achieving Balance with One Shape

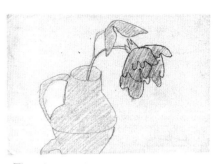

This painting illustrates how to plan a composition for balance. I had picked this rose from my garden. The only container that I could find to fit it into was an odd-shaped coffee mug. The combined shape of the rose and the mug was one that I thought would work well for a painting.

The shape of the subject was obvious, but I had to decide where to place it on the page. By putting the mug in the lower left and the rose in the upper right, I achieved a well-balanced composition.

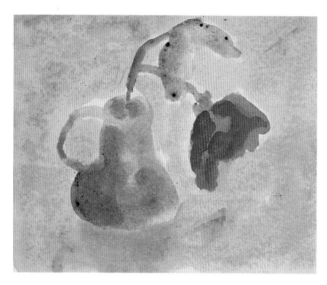

In my color study I loosely blocked in the colors I thought would work well for this piece. I wanted them to balance, so I placed the same colors in opposing sections of the format. Notice the red in the flower, stem, and mug; the green in the leaves and cast shadow.

Step 1. *Since the subject was such a simple one, I took the time to capture the subtleties of contour in my initial pencil drawing.*

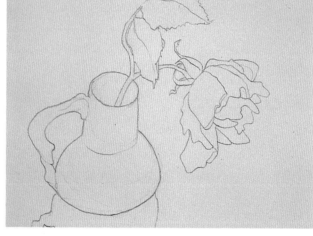

Step 2. *I covered most of the surface with a light green wash. This use of a "mother color" helps to unify all the colors in a painting because it combines with everything that goes on top of it. Because this was watercolor, I left untouched areas in the paper for the lightest values.*

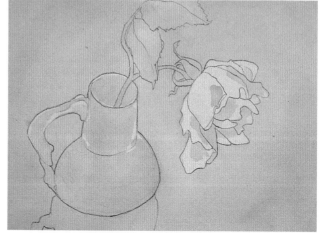

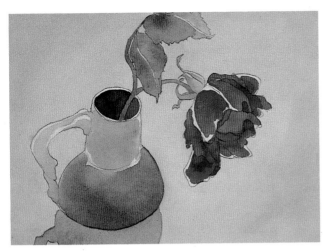

Step 3. *Basically I followed the color placement of my study. To enhance the color harmony, I floated some red in the purple mug to show reflected color and used purple in the red flower for darker value. What looks like brown in the opening of the mug is actually layers of purple and green, colors I had already used in the painting.*

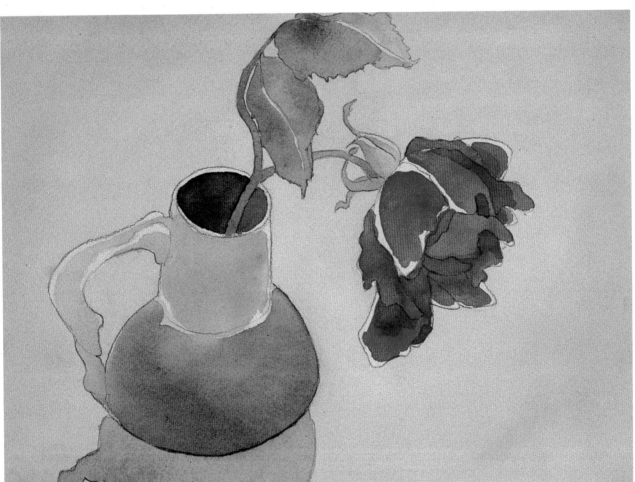

RED ROSE, *9″ × 12″ (23 × 30 cm), watercolor*

Finished painting. *In the final stage I intensified all the shadows. I darkened the bottom of the mug and the cast shadow to balance the strong color of the rose. I developed the patterns within the leaves and added a blue wash to the background, varying the color and intensity to make it appear less flat.*

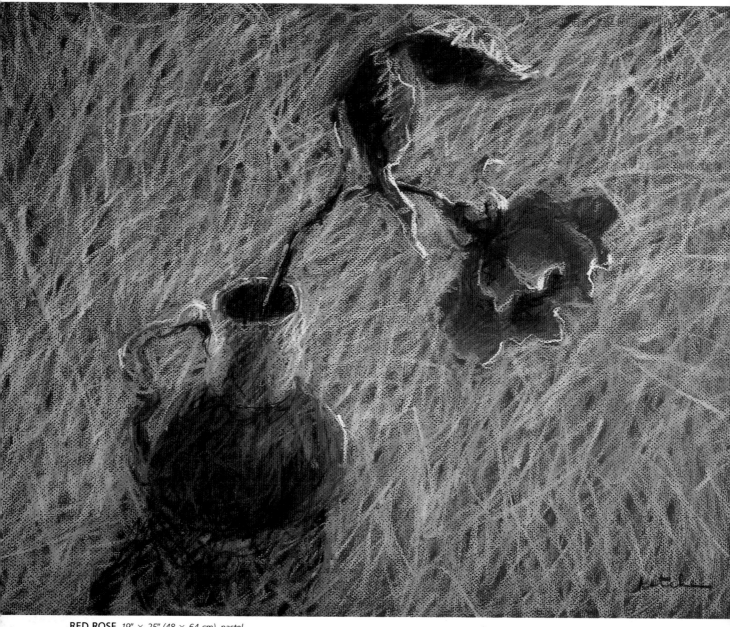

RED ROSE, *19" × 25" (48 × 64 cm), pastel*

I was pleased with the watercolor, but decided to take the image one step further. Using the same basic divisions of shape, color, and value, I enlarged the image for a pastel painting. Again I built up the colors in layers, but here the layers were scribbled strokes rather than smooth washes. Notice the extra vitality provided by the strong, loose pastel strokes.

Demonstration
Exploring One Subject

When painting any subject, take the time to study the particular object or objects you are portraying. Any one flower, for instance, can present you with many ideas for a painting—using different light, different angles, or different stages of its development.

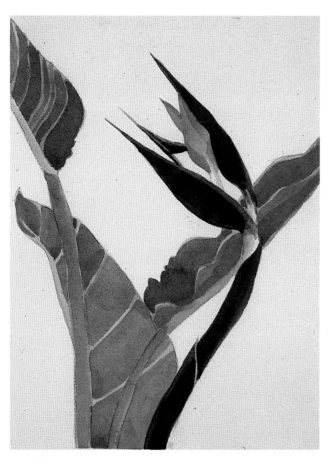

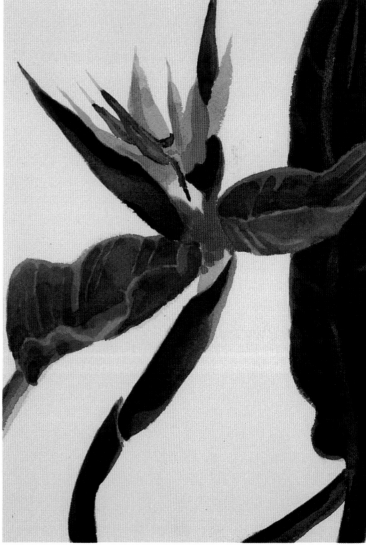

By painting a whole series of this bird of paradise, I gave myself the opportunity to try out different media, different colors, and different compositions. The three studies shown here, which were done in watercolor, depict the flower in three stages of bloom.

For the large pastel painting shown on the following pages, I changed to a horizontal format and decided to include more of the foliage, using the long stems and leaves to divide the negative space into interesting shapes.

Step 1. *Even though I planned a light background, I decided to use black paper. With the loose pastel stroke I intended to use, I knew some of the paper would show through, creating a dramatic contrast. I did my basic drawing in orange because it would be easily visible on the black. I placed the flower, the focal point, slightly to the left of center so that it would be central but not absolutely symmetrical.*

Step 2. *I began developing the color of the flower right away because some of the petals were beginning to fade and wilt. I wanted to capture them before they changed. Next I filled in the negative space with a light lavender color. Leaving the black shapes of the foliage against the background helped me see how the composition would work.*

Step 3. *Satisfied with the placement of the leaves and stems, I began to block them in with several green colors. I wanted to firmly establish the values and patterns, knowing that with pastel I could easily go back and soften the contrast.*

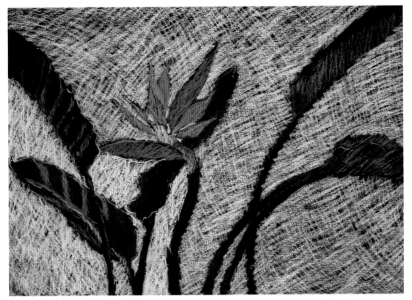

Step 4. *I blocked in the final shapes, the leaves of the flower, with a blue-green and planned to add some of this same color to the stems and leaves. Repetition of color is one of the best ways to achieve harmony.*

In the background you can see how I develop colors. The background was first one layer of diagonal hatched lines. I added another layer of hatching in the opposite direction, which is evident on the right side of the background. In order to get rid of the harsh, geometric texture, I then began adding another layer of light color, this time with a loose, irregular stroke like a scribble, which can be seen in the lower left corner.

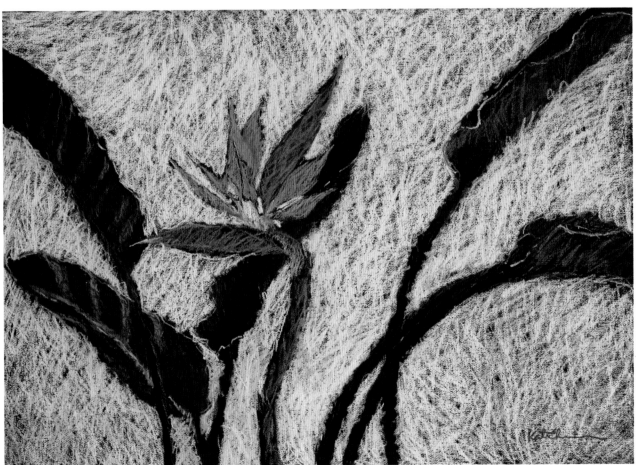

BIRD OF PARADISE, *27½" × 39" (70 × 99 cm), pastel, courtesy Lizardi-Harp Gallery, Pasadena*

Finished painting. *In the final painting the total background is covered with a loose, random stroke. I softened the patterns in the leaves a bit and took the colors from the flower into the rest of the plant. Notice the accents of yellow that add punch to the final color.*

3 Planning the Values for a Painting

Among the elements that must be planned for a painting, one of the most important is value, the variation in lightness and darkness. A good way to begin to see value is to study black-and-white drawings and photographs, where the entire image is delineated just by value. Without color, only the contrast between darks and lights shows us what is there.

In works done in color, value is less obvious but still vital. It is not black, white, and grays that we use to build our composition, but light colors against dark colors.

Why is value so important?

1. Value differentiates shapes within a composition. If an image consists of shapes that are all of the same value or darkness, we cannot see them. All we see is one big shape. By varying the values, we can make the shapes visible.

2. Value indicates light. It is with value that we show how much light is shining on a subject and also the direction of the light source. When we see a very dark landscape, we assume it is either nighttime or a very overcast day. If a solid object is bright on the right side and dark on the left, we assume that a light is shining on that object from the right. The use of value gives us much information about what is happening in the scene.

3. The solidity and depth of a painted scene are made convincing with value. We can take a simple rectangular shape and, by shading the vertical or horizontal edges, create an illusion of roundness. We can make a mountain range appear to fade off into the distance by adjusting the values.

4. Value helps create visual interest. If you want a painting to grab your attention every time you walk past it, give it a full range of values, from lightest to darkest. This does not have to be from white to black; it can be from light ochre to dark purple. We are not concerned here with color, but with darkness. For a very dramatic effect, try using high contrast—extreme light and dark values without any middle tones.

5. The emotional impact of a painting is determined to a large extent by value. Try this exercise with word associations. Say the word *light.* What words come to your mind? Bright,

happy, open? Now say the word *dark.* What words do you think of? Heavy, serious, closed? If you want to control the emotional impact of your art, you have to control value.

Learning to See Value

To begin, learn to recognize value in black-and-white images. First look for the darkest darks in the piece. Next locate the lightest lights. Now notice the various grays in between.

Then try the same procedure with color. Again look for the darkest darks; they might be red, blue, purple, green, or brown. Don't be concerned about color; look for darkness or value only. Next find all the lightest shapes, again in any color. Then look at the range of values in between.

Have you ever photographed a color painting and found that even though it seemed strong and interesting in color, it appeared dull and lifeless in black and white? Probably there wasn't much value contrast. There might have been lots of colors, but all were pretty much the same lightness or darkness.

Sometimes you might want a painting that is all one value. You might be trying for a serene or peaceful mood where strong value contrast would be inappropriate. That is fine—just as long as the use of values is deliberate.

There are some easy techniques to help you see value. One method that portrait painter Constance Pratt uses is to look at a painting through a red sun visor or a red piece of cellophane. The red makes the painting appear all in one color so that she can easily check the values.

Another technique is to use a gray scale. This is a chart that shows the variations of gray from white to black. You can also make a "gray" scale for any color. Fill the first square of a row of empty squares with the lightest shade possible of the color. Then fill the next square with the same color, only slightly darker. Continue until you fill the last square with the darkest shade possible.

To use this scale, hold it against a particular area in a painting. Compare the darkness of the values. For maximum value contrast, your painting should contain all the same values that exist in the gray scale.

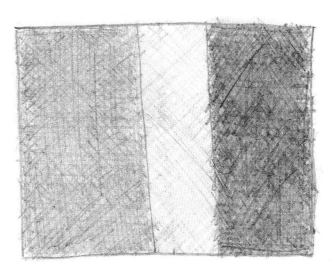

Value can be used to differentiate shapes. In the first example we can hardly see the separate shapes, but when we change the values, they become quite obvious. This is an important concept to use in a painting when you want various elements to be distinct from one another.

It is value that lets us show light. In this drawing we assume there is a light source shining from the right because the right side of the form is light and the left side is dark.

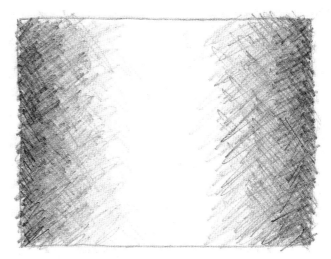

Here we create a sense of volume with value. The lightest area seems to be closest to us and the darker edges appear to recede.

In these two examples we see how visual interest is intensified with value contrast. Here the pattern is developed with two light grays; it is mildly interesting.

This example, with its stronger contrast between light and dark, has much more impact.

A gray scale is simply a row of boxes of graduating values. This kind of scale can be made with gray or any color. You can use it to judge the value contrast of a painting or drawing by comparing the scale to values in the art. A strong painting will usually have values that correspond with several levels of the scale.

This striped pattern shows the impact of high contrast. By using only the extreme ends of the gray scale, you can create a pattern where the values seem to bounce against each other.

By gradually changing values from light to dark, you can create movement in a composition, leading the eye from one value into the next.

These are three examples of value created with texture. Middle values do not have to be made with solid gray pigment. Any repeated shape or stroke will create a middle value. I often use textures to create middle values for the sake of adding visual interest to a section of a painting.

GAYLE AT VENICE BEACH, *12" × 9" (30 × 23 cm), watercolor*

It is the use of value that convinces us that this figure is sitting in strong sunlight. Notice the definite contrast between the light and dark sides of her face and neck. If the contrast between the highlights and shadows were more gradual, we would assume the figure was in a more diffused light, perhaps indoors.

ROSE PETALS, *39" × 27½" (99 × 70 cm), pastel*

Demonstration
Achieving Value with Color

In *Rose Petals* (opposite), value contrast is important because it gives form to the roses. If the blossoms had been painted all in one value, they would have looked flat and unreal. Instead they look very solid, with each flower having its own three-dimensional shape. In these details you can see how I developed value with color.

Step 1. *I began with a contour drawing showing the basic shape of the flower and leaves and indicating where the shadows would go.*

Step 2. *I loosely marked the background shapes with a light color. I was building this painting with a more complicated palette than usual. My greatest concern was to use light colors for the light values and dark colors for the dark values.*

Step 3. *I layered strokes of light to middle pink for the lighter area of the rose and burgundy and reds for the shadow area. I was using a loose, scribbly line that became more solid as I added more layers of strokes.*

Step 4. *After I had built the basic pinks and reds of the blossom, I added bright highlights with a warm light ochre. In the shadows I added accents of cool blues and violets. Generally when an object is in warm light, the shadows will appear as cool colors, and vice versa. The leaves and stems were mostly rendered with a variety of dark colors and the background was filled in with layers of very light blues and lavenders.*

Composing with Value

Value is just as important as shape in building a composition. The principles for arranging values are similar to those for shapes, but now the compositional elements are balance and contrast.

Balance again is a vital consideration. You can think of value in terms of weight, with each side of the composition like one side of a scale. If you put all the dark shapes on one side, that side will be heavier and will appear to be falling. The dark shapes do not have to be symmetrical or even similar; they just have to provide the same weight on each side. This balance should hold up no matter which way you divide the composition in half.

The other important element is contrast. It is contrast that gives visual interest to a painting or to a part of it. When everything in a painting has a fairly even value, the eye moves randomly from one part to another or does not move at all. If the same middle-value composition is given one section of high contrast, the eye is immediately pulled to the contrasting spot. If you want more impact in an area, give it more contrast.

There are different kinds of contrast. For optimum drama you can use high contrast; put an absolute dark next to an absolute light and the result is a feeling of impact. In figure paintings the light skin tones of the face often are encircled by dark values of hair and background. This reinforces the face as the center of interest.

Another kind of contrast is gradual contrast, what we think of as shading. Put a light value next to a darker value next to an even darker value. The result is a sense of movement, with the eye being led from one value to the next.

Still another effect is texture, creating a pattern by repeating areas of contrast. Repeating strokes or shapes creates texture. The textured area assumes a shape of its own whose value is an average of the values within it. For example, an area filled with white and black strokes will have an overall value of gray.

Using Value Studies

Value is a component of painting that is too important to leave to chance. From the time I first consider painting a subject, I think of it in terms of value. Is the subject naturally divided into a variety of light and dark shapes? Do the highlights and shadows make an interesting pattern? Can I balance the dark areas? Is there enough contrast?

I continue to think about value in a general way until I start my preliminary composition studies. Then I generally begin by organizing my basic shapes in a simple line drawing. Either in the same drawing or in a separate value study, I draw in the darks, lights, and grays. I look at the subject and reduce it in my drawing to the basic shapes of the contrasting values.

I generally execute my value studies in black and white. I might use pencil, charcoal, ink, or paint, whatever is handy and will allow me to differentiate the various lights and darks. These are often quite small drawings, sometimes merely thumbnail sketches, designed to show the basic overall pattern of lights and darks.

Showing the lightest and darkest values is simple. I leave untouched paper for white and use heavy, solid pigment for black. (It is also possible to work with light pigments on black paper.) With the grays you can be more inventive. There are so many ways to create middle values. With pencil you can adjust your pressure; with charcoal, blend the chalk; with ink or watercolor, dilute the pigment with water.

Then there are the more adventurous techniques—hatching, scribbling, stippling, and any other way you can think of to make a texture. Use your value studies as an opportunity to play with textures. Adding a variety of textures to your paintings will give them a greater richness.

When I am ready to start the final painting, my value study becomes an important guide. When I am blocking in the initial shapes and later as I refine the image, I compare the painting to the value study so I can control the lights and darks.

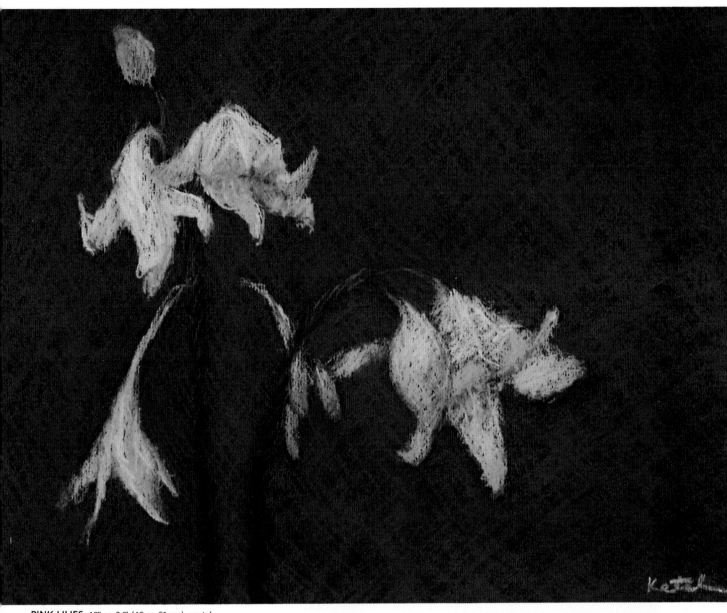

PINK LILIES, *18″ × 24″ (46 × 61 cm), pastel*

In the small format of the study, this composition seemed to work very well with a range of middle to light grays. The flowers were rather delicate, and I wanted to keep the whole painting soft in tone.

When I began to work in a larger format, however, the minimal value contrast seemed dull. I gradually crosshatched layers of darker background color until I achieved a more dramatic contrast against the white and pink flowers. Even though I changed the values, the study was important because it gave me a point to work from.

Demonstration

Developing Unexpected Values

Since I usually paint flowers against light backgrounds, I wanted to try one against a dark background to discover what kind of impact that would have. The principles of balance and contrast are the same whether the background is light or dark.

Step 1. Since the purpose of this watercolor was to develop unexpected values, I started by laying in a fairly dark brown for the negative space. It gave me a standard for comparing all the light colors I added later.

Step 2. Next I blocked in all the light shapes. I was careful to leave accents of unpainted white paper, since I knew the white would provide dramatic contrast with the dark background.

Finished painting. I further developed my light colors, establishing volume within the flowers and leaves. Notice that it is the relationship between lighter and darker values that makes the various shapes look rounded. My final task was adding enough washes of brown so that my background became a rich, intense dark. Notice how the white accents seem to glow against the very dark values.

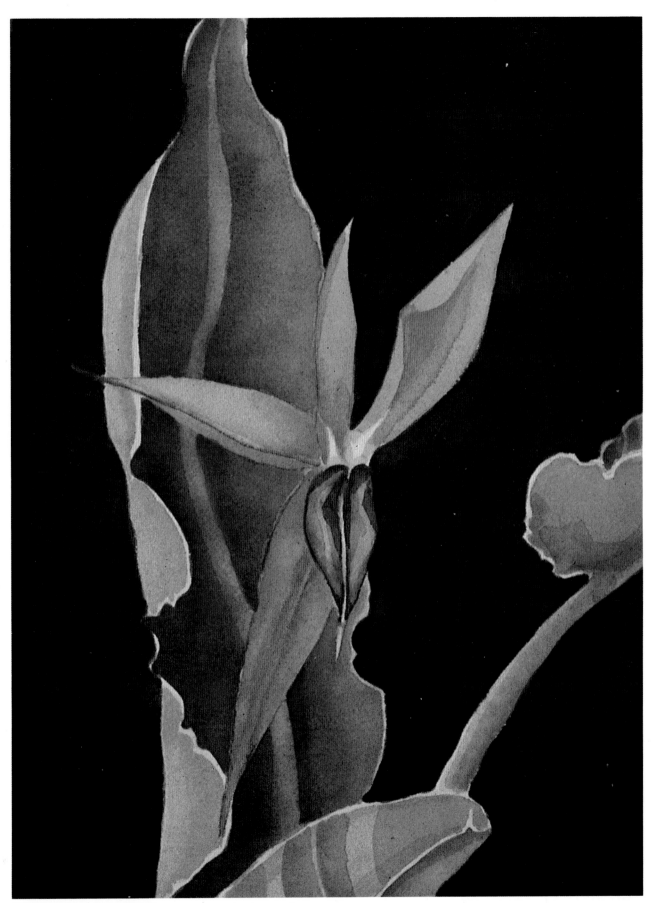

STANDING BIRD OF PARADISE, *16" × 12" (41 × 30 cm), watercolor*

For this painting I knew how I wanted the figure placed and posed. What I needed to work out in the value study was how to divide the negative space in an interesting way. I decided on a pattern of dark against light rectangular shapes. Notice the stippling in the dress. I was not planning a polka-dotted dress; this was merely a texture to indicate a middle value.

Notice how the geometric shapes of the background, besides providing value contrast, are a counterpoint to the softly curving shape of the figure. Another interesting element of composition is the opposing triangle created by the rounded shapes of the tables and hat. Even in a painting where a single figure is the most prominent feature, the elements should work together to make a strong composition.

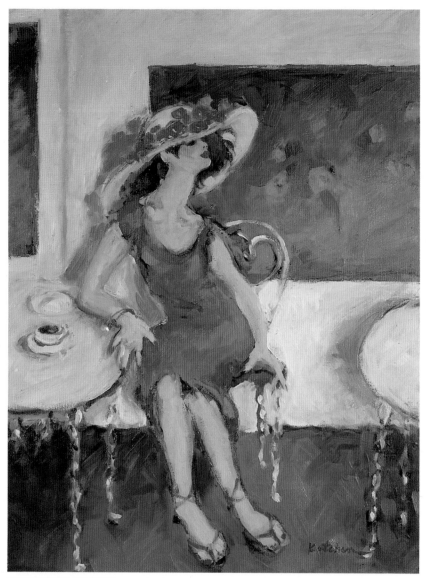

ROSIE AT THE MARKET, 24″ × 18″ (61 × 46 cm), oil, private collection

Value can set the whole tone of a painting. The subject of this painting is the spring wind. I have made it a strong wind, wildly blowing the girls' hair, their dresses, and the trees. If I had used a lot of dark values in the scene, I would have created the feeling of a threatening wind, the harbinger of a storm. So I kept all the colors light and soft to give the feeling of a friendly spring wind. Restricting value contrast is acceptable if it enhances the painting.

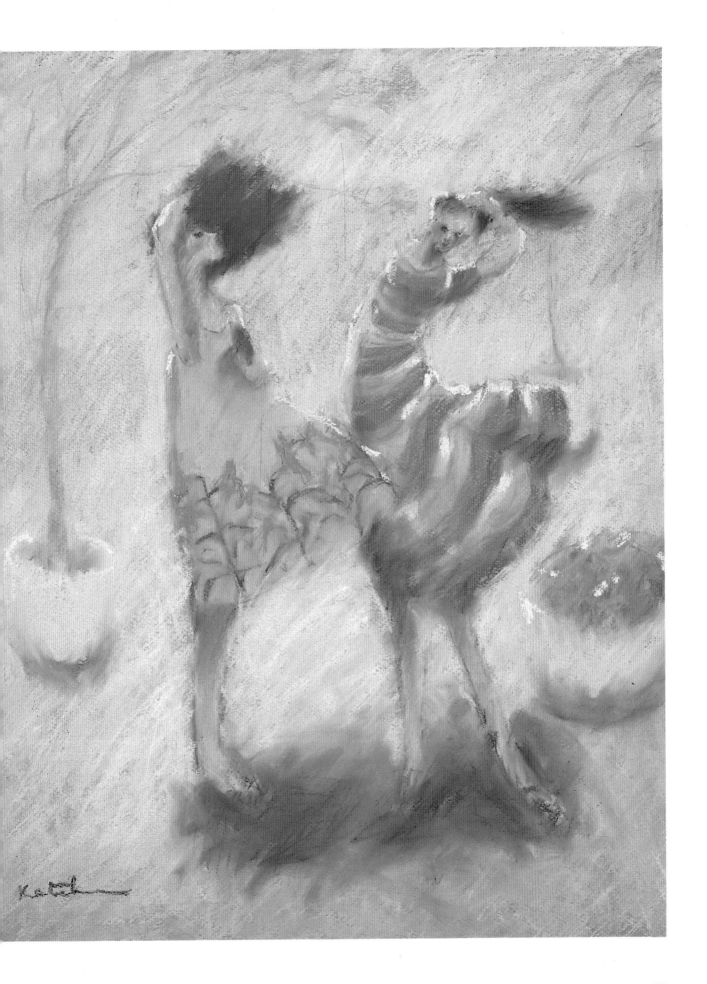

Playing with Grays

Begin by creating a gray scale. Draw a chain of five empty squares on a sheet of white paper and leave the square on the left absolutely white. With charcoal or a very soft pencil, make the last square on the right as dark as you possibly can.

Next fill in the middle square. Using the same charcoal or pencil but applying less pressure, make the center square a middle gray. Now on the second square from the left, between white and middle gray, add a light gray. In the final square fill in a dark gray, halfway in value between the middle gray and the black.

Using the same charcoal or pencil, begin a drawing on another sheet of white paper. Choose any subject you like. As you proceed, hold the gray scale against various sections of the drawing to see which of the values you have already established. By the time you complete the drawing, there should be at least one segment that corresponds exactly with each of the squares on your gray scale.

This exercise will show you how to develop a drawing with a wide value range.

By comparing the different values of the gray scale to the rendering of the apple, you can determine how wide a range of values has been used in the drawing. This piece contains all five values. The pure white is in the highlights. The light grays are on the top and side of the apple, and the darkest grays are in the cast shadow.

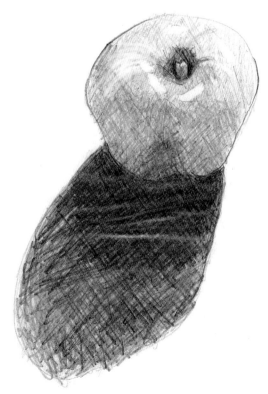

Demonstration
Composing with Value Contrast

One of my favorite opportunities for drawing jazz musicians has been the Gibson Jazz Concerts in Denver. Dick Gibson periodically pulls together a number of jazz greats, puts them on stage, and lets them create music. The musicians play in groups and solo, so during the concert there are many opportunities to draw each one. Developing value is important in any painting, but it was critical here because of the theatrical lighting on the musicians.

In my drawings at this particular concert, I concentrated on major physical characteristics and gestures; I was too far from the stage to see fine details. The high-contrast stage lighting and the dimness of the auditorium also made it hard to do intricate work, so I tried to capture general impressions.

The value study helped me organize the composition in large shapes of light and dark. When I work with a cluster of figures like this, I think of them as one shape. In this piece the cast shadows also became an important part of the composition.

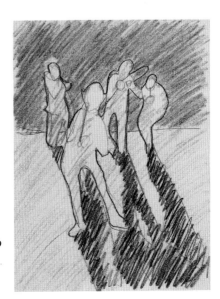

89

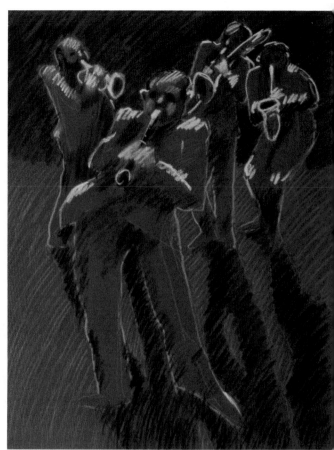

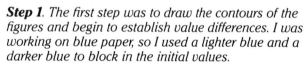

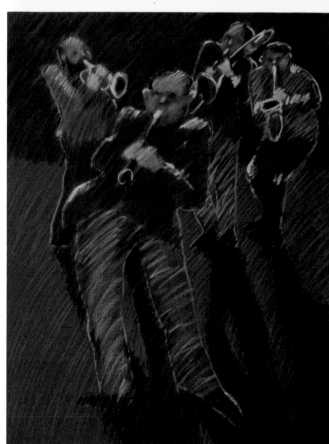

Step 1. The first step was to draw the contours of the figures and begin to establish value differences. I was working on blue paper, so I used a lighter blue and a darker blue to block in the initial values.

Step 2. Next I established the highlights and shadows within the figures. I planned to use exaggerated value contrast to give a sense of the theatrical lighting.

Step 3. After the values were set, I added local color, the colors of the skin and clothing. I left the background in the same, simple blue values that I had already established. I planned to keep blue as the dominant color of the painting.

Finished painting. In the last stage I went back into the figures with blues and violets to unify the total color. I added light blue and light ochre for highlights. Then to give the piece a little more excitement, I added accents of orange, the exact complement of blue. Notice how the orange seems to jump out of the blue; that will happen whenever you put complementary colors next to each other.

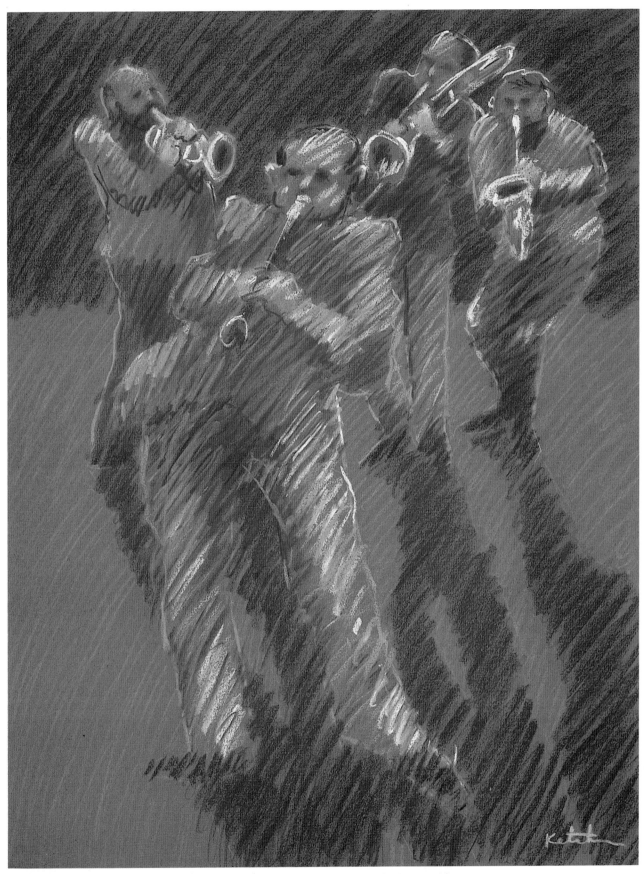

PEANUTS HUCKO, *25" × 19" (64 × 48 cm), pastel, collection Northwest Community Hospital, Arlington Heights, IL*

4 Planning the Colors for a Painting

One of the first axioms of the professional art world is that color sells paintings. A virtuoso piece of art in black and white might be so wonderfully rendered that it makes people stop in awe. Even though people say the piece is great, however, in most cases the painting they will buy is one with color.

Why is that? It probably has to do with the emotional appeal of color. Composition and value might be the bones and flesh of a painting, but color is its personality and perhaps its soul.

Different Approaches

There are as many different approaches to color as there are artists. Many painters, especially beginners, think of color in a simple, literal way. An apple is red; a banana is yellow; grass is green; the sky is blue.

More advanced realists go a step further. Not only is an apple red, but it is a warm red in the light and a cool red in the shadow, a bluish red where it reflects the blue cloth next to it, and so forth. Artists like the German Expressionists look at the symbolism and emotional impact of color. Red is violent; blue is cold. An expressionist might paint a face purple because the model looked sad.

A third approach to color, the one that I use, is to paint a general impression of colors without being completely tied to reality. In my pastel painting *Fruit*, I took many liberties with color. I used the same basic red, greens, and violet throughout the painting. These were not the exact colors of each piece of fruit, but they are understandable to the viewer and work together to create a strong total color composition.

A Four-Step Plan

Any approach to color is valid as long as you continue to use the basic design principles of harmony and contrast. The way you achieve those is with careful planning. I recommend a four-step approach to planning color:

STEP 1 First of all, take the time to study the colors in your subject before you start to paint. I am not talking here about a superficial glance, but a serious, in-depth survey of all the colors. Only when you know what colors are in your subject can you decide which are the most important to use.

Don't look just at the green in a tree; look at all the different greens in that tree. Look for reflected colors and hidden colors, the tiny details of color. Even big, flat areas of color vary from light to dark or warm to cool. Take the time to see all those subtle changes.

That is how I began the work on *Mountain Grasses* (page 95), seeing the abundance of color in the scene. The meadows comprised many greens, browns, grays, and ochres. The colors in the trees and tall grasses ranged from purple to bright gold.

STEP 2 Once you become aware of how many colors are actually in your subject, you need to simplify. Squint your eyes so that once again the colors blur together into simple, solid forms. Look for the largest shapes in your subject and see what the dominant color of each one is. It is helpful to find three or four basic colors of differing values. This helps you develop value and composition at the same time that you are planning color.

These first two steps are carried out before you even touch your art supplies. You are working with your eye and your mind.

With *Mountain Grasses* the scene divided itself into a few obvious shapes: the green, grass-covered meadows; the blue sky; the brown path; and the darker details of the trees and tall grasses. These are shown in the diagram on page 94.

STEP 3 Next you select or blend colors to match those of your simplified view of the subject, and you use those colors to paint a simple color study. As you lay out your design of simplified colors and shapes, concentrate on harmony and contrast.

For instance, in my watercolor study of *Mountain Grasses*, I worked with a palette of three colors—blue, green, and brown—plus some unpainted white in the tall grasses. The warm brown and cool blue provided contrast. I got value contrast by layering some of the colors to make them darker. Harmony came by painting a brown wash under the green areas, thus making the

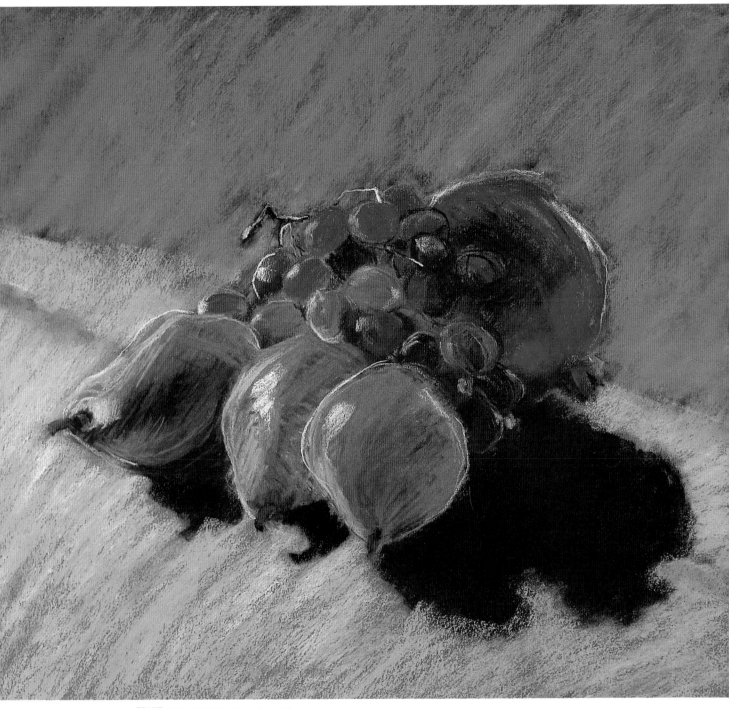

FRUIT, *16" × 20" (41 × 51 cm), pastel*

Even when I am painting a realistic subject, I don't feel compelled to use totally realistic color. My goal is to create the illusion of realism while developing a strong painted image. Here I used the same red, greens, and violet in all the fruit even though there were actually many different colors in the grapes, pears, and pomegranate. This repetition of color gives greater solidity to the painting, which I think is more important than an accurate representation of the colors. Again I used complementary colors in a painting for maximum contrast; notice how the red and green work together.

Before beginning the pastel painting shown opposite, I worked out the basic color design in a study. I analyzed the multitude of colors in nature and reduced them to a manageable palette of three—green, brown, and blue. No matter how intricate the actual view is, the artist must be able to pick out just the most important color shapes as the basis of a painting.

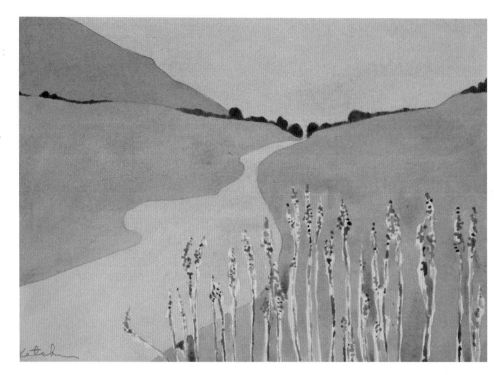

This diagram shows how an artist can look at a complex scene and reduce it to just a few main shapes for color.

In this detail of the sky we can see how many different colors blend together to create the blue. The bits of brown paper that show through here are also apparent in other parts of the painting, adding to the color unity of the total piece. I left the strokes unblended so that the surface texture would be more vital.

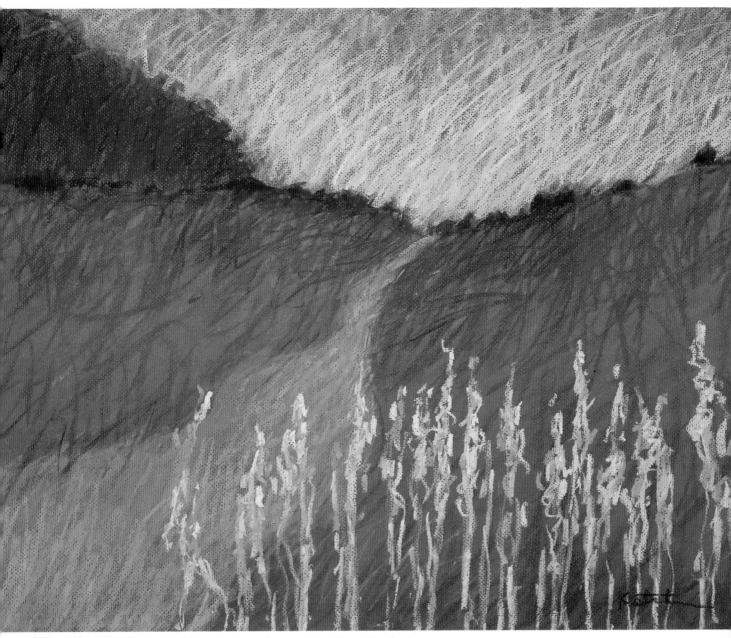

MOUNTAIN GRASSES, *19" × 25½" (48 × 65 cm), pastel, courtesy Lizardi-Harp Gallery, Pasadena*

You can see that the basic color shapes in the final painting are the same as in the color study, but I added intensity and variety to the colors. I used pastel because the technique of crosshatching allowed me to build color slowly and assess it as I went along. To achieve each area of finished color I applied many layers of colored strokes.

In this detail you can see that there are strokes of the same brown color in both the brown path and the green meadow. Color repetition adds to a painting's harmony.

meadow relate to the path. Also, repeating the green in several places added to harmony.

In Chapter 2, I explained how dividing my subject into a few big shapes helps me to develop composition and value. It also helps me to develop color. It is much easier to see and control the relationships between just a few large areas of color than among an intricate kaleidoscope of many colors. There is a temptation to use more colors, thinking that more colors will make a better painting. That is not necessarily true. Uncontrolled color leads to chaos and disharmony.

STEP 4 The final step is to orchestrate your colors, to develop a richness of color in your finished painting. The previous steps help you decide on a basis for using color in a painting. The final stage is a matter of refining color, value, and color temperature.

After I have laid out my basic colors, I decide which of the additional colors in my subject will enhance the total image. Then I incorporate those into the final painting.

In *Mountain Grasses* you can see how I took the basic colors of shapes and made them more complex. For example, the sky area is basically blue, but there is a gradation from the deep blue at the top of the sky down to a soft violet near the horizon. In a close-up view of the sky, you can see how I used strokes of light and dark blues, aqua, and violet to build that one solid area of color.

Again I developed harmony by layering and repeating colors. See how the underpainting of the brown, the color of the path, shows through the green of the meadow? In the path itself I added some of the violet from the sky.

For contrast there is a gradation of color in the sky and the path. More contrast is provided by the dark brown and purple of the trees and the bright yellows and gold in the tall grasses.

Using Color Studies

The primary purpose of a color study is to help you choose a palette of colors and see generally where they should be placed in the painting. You can usually tell quickly how your basic colors will work when you paint them into the simplified shapes of your composition. Color studies can be simple or complex, and they can be done in whatever medium you prefer.

If the basic colors you have chosen don't work in the color study or if you are just not sure that they are the best combination, start over with another palette. Often I try many combinations before I arrive at the one I will use in the final painting.

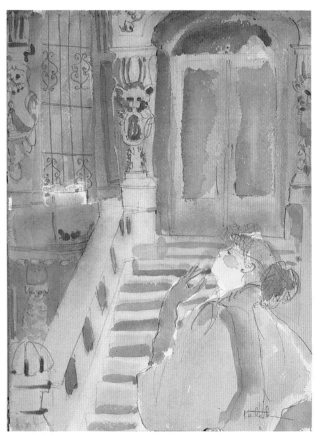

CENTRAL PARK WEST, *12″ × 9″ (30 × 23 cm), watercolor, Courtesy Gallery of the Southwest, Taos, NM*

I had a drawing of this wonderful character and needed to find the right background for her. She was sitting in front of me on the airport shuttle into Manhattan. I loved her hat and large, flowing coat, so I did a sketch as we rode into the city.

As I walked around Manhattan, I kept looking for an appropriate background. I found this stone façade just west of Central Park and went back with my watercolors. First I drew the figure onto my paper and then I added the shapes and details of the building. Notice how I used color to unify the two elements of the composition, taking the blue of the clothing up into the building. I deliberately kept my colors light; I was afraid that dark, heavy colors would turn the image into a Gothic scene.

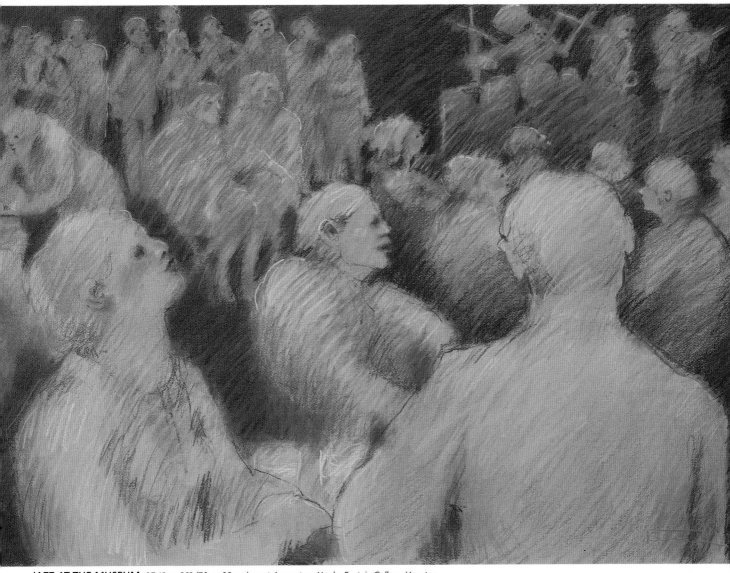

JAZZ AT THE MUSEUM, *27½″ × 39″ (70 × 99 cm), pastel, courtesy Hooks-Epstein Gallery, Houston*

The Denver Art Museum has a Wednesday night jazz series. Some people attend to see the art or to listen to the music; I like to watch the crowd. For once I was without drawing paper, so I recorded this scene on a paper napkin.

Because this was such an involved scene with so many figures, I decided to establish the values first. I started with a dark blue pastel pencil on gray paper. First I blocked in the dark areas with the deep blue. I developed the middle values with lighter diagonal hatched lines of the same blue, then I marked highlights with a very light blue. Finally, when I had established all the values, I added local color to the piece. I used mostly warm colors—ochre, pink, rose, and burgundy—to balance the coolness of the gray paper and blue underpainting.

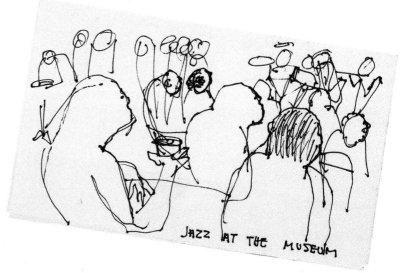

I had finished this large drawing and was very pleased with the gesture and expression. Although I do believe that monochromatic drawings are as valid works of art as paintings, I kept thinking that this image would be stronger in color.

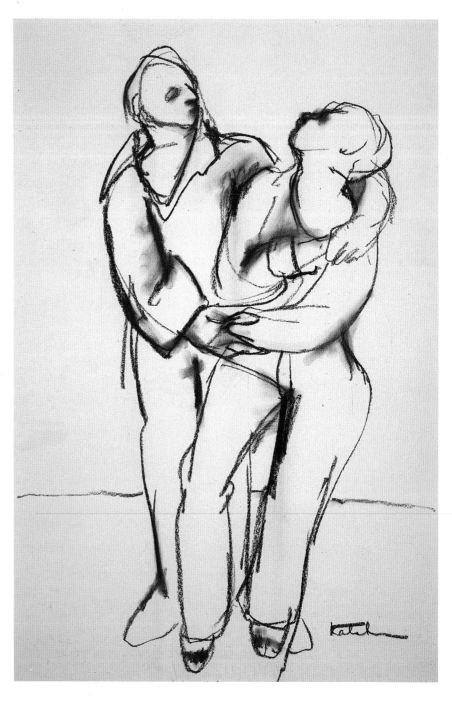

SWING DANCERS 1,
34" × 22" (86 × 56 cm), pastel

Finally I took the drawing out of my flat file and decided to add color. First I developed the negative space. I thought of it as three horizontal shapes, with solid colors at the top and bottom and a row of vague figures across the center. With the composition set, I added color. I used pastel, flattening the color in some areas with a brush and water. Notice the brushstrokes in the woman's legs. I kept my colors flat and simple so that the gesture and expression would still be prominent. Comparing the two versions of the same piece, however, you can see how much warmth and solidity were added by the use of color.

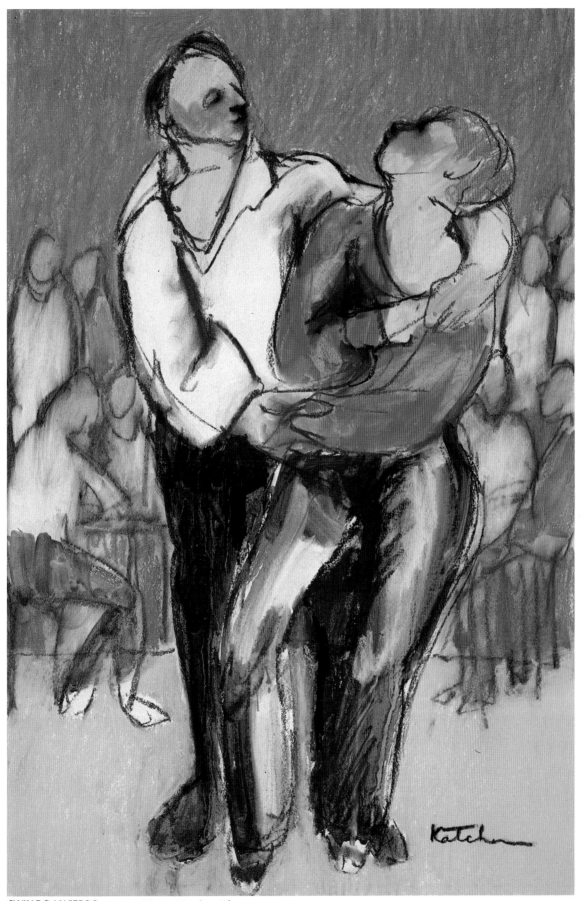

SWING DANCERS 2, *34" × 22" (86 × 56 cm), pastel*

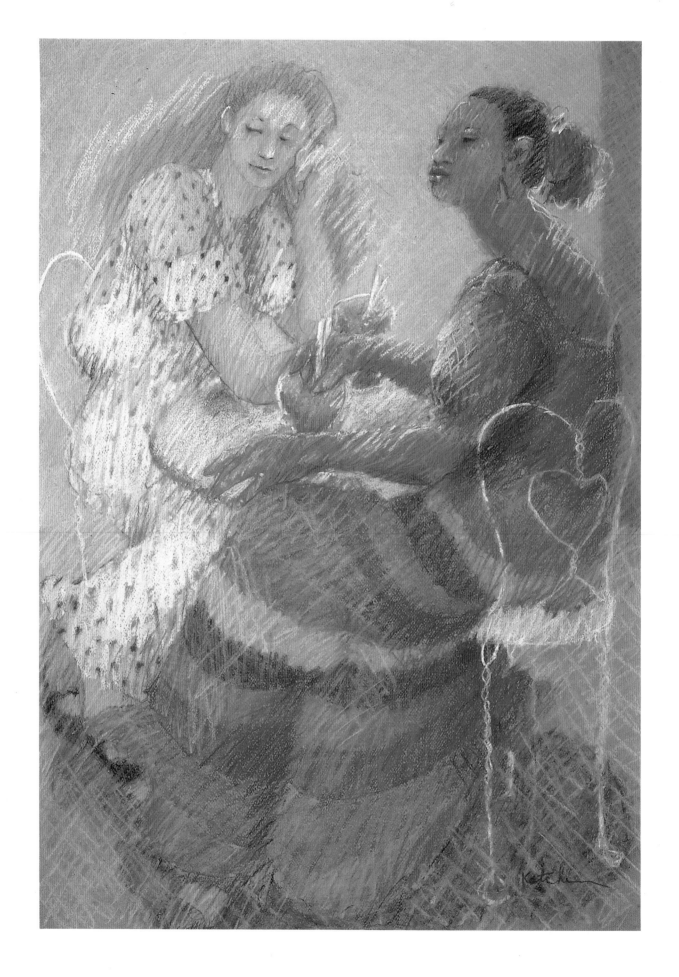

Repeating Colors

Let me stress one of the techniques that I used to provide harmony in *Mountain Grasses*—repetition of color. Especially in a complex painting where there is a profusion of colors, repeating the colors will make the composition appear more balanced and unified. Many artists follow the rule of never introducing a new color unless it can be used in more than one spot. Putting the same blue, for instance, into several areas will weave that blue into the texture of the piece, making it look well designed.

Look at my pastel *Summer Dresses* (opposite). Although there are only two figures in this composition, the strong patterns in the dresses create a very complex design. To keep the colors from looking chaotic, I repeated several of the same colors in both dresses.

Repetition can also be a good way of uniting separate elements within one painting. *Central Park West* (page 96) was a combination of two totally separate images. I had drawn the woman on a bus. Later I found the façade of a building to use as a background. When I painted the two fragments in one composition, I deliberately used the same blue in her costume and in the shadows of the window and the doorway. The repeated blue helps to integrate the total scene.

Relating Color and Value

No matter what you do with color, you still have to maintain value contrast. In *Mountain Grasses* I put in color first and then added value. It is also possible to work the other way, putting in value first.

SUMMER DRESSES,
39" × 27½" (99 × 70 cm),
pastel, private collection

Although this painting is a very complex arrangement of shapes and colors, the image is unified by the repeating colors in both dresses. Before I began, I tried out different combinations of colors. I was especially concerned about the striped dress because it is such a prominent part of the painting. On a separate piece of paper I tried out different combinations of stripes to see how each pastel color worked on the colored paper and how the colors worked together. Often colors will look different because of neighboring colors; they can optically blend together or magnify the contrast. I decided on the colors for the stripes and then used them to develop the rest of the composition, only adding a burgundy for the darker values.

Many old masters used the technique of blocking in values first and then adding local, or specific, color. Painting in oil, they would first use brown to establish their basic values. They would build up the dark areas with transparent brown glazes and then transparent glazes of other dark colors. They placed the highlights last with light opaques.

I often use this approach with pastel and watercolor as well as oil. I might use blue, violet, or any other dark color to lay in my dark and medium values. Then I add my local color on top. One advantage of painting this way is that the color of the underpainting gives color unity to the piece.

Building Colors

Many artists mix their colors on a palette and apply them to the canvas in a single layer of strokes. I prefer building colors within the painting. With watercolors I use layers of washes, or glazes. With oil or pastel I build layers of individual strokes.

One advantage of building colors gradually is that it allows more time to assess the relationships of color and value as you proceed. You don't have to get the color exactly right with the first stroke but can adjust and adapt as you go along.

Another advantage of pastel and oil, where you layer individual strokes of color, is that your finished colors have much more vitality. Instead of a flat surface of one solid blue, you can build an area of blue that actually comprises individual strokes of many blues and any other color that you want to add. You can add strokes of yellow or red to warm the color; strokes of orange to gray it. This gives the viewer a solid color to look at from a distance, yet a more interesting variety of colored strokes up close.

Playing with Color

There have been volumes written about color theory: What happens when you mix primaries? What happens when you mix complements? What happens when you juxtapose complements?

My feeling is that the best way to learn what colors do is to experiment with them. Play with color. Do color studies in preparation for paintings, but also do them just for the fun of it.

Use many different media for your studies. If you have never painted with watercolors, try them for color studies. You can freely experiment with washes, drips, and splashes, knowing you are only doing a study. Besides learning to plan a painting, you gain first-hand knowledge of how a medium expresses color.

Demonstration
Building Color in Pastel

This pastel painting is a good example of how an artist can build solid color by adding layers of individual strokes. Because it is one of a series of paintings I did of roses in glass containers, it needed a design different from those I had done before.

In the first drawing I worked on placement. Basically I put all the roses on the right side and balanced them with the glass and leaves on the left. From drawing roses, I have learned that each blossom has its own unique shape. In the second drawing I was studying the shapes of the four different flowers.

Step 1. *I drew my subject with orange, a color that was easily visible on the black paper and would blend with the colors of the flowers. The light areas on the paper were due to the previous smudging; sometimes I erase unplanned colors, but in this case I thought they might make the background more interesting.*

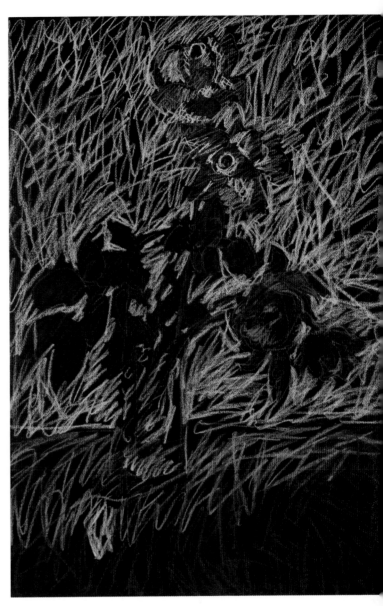

Step 2. *Here you can see how I develop value with color. I divided these two blossoms into light, medium, and dark areas, then selected one color for each value. For the highlights I chose a warm, light yellow; for the middle tones, a pink; and for the shadows, a cool violet.*

Step 3. *I blocked in the other flowers with reds and pink. Then I blocked in all the other shapes of the painting. I used only one color in the background, but in the foreground I used two colors, overlapping them in the middle to create a gradual value change.*

103

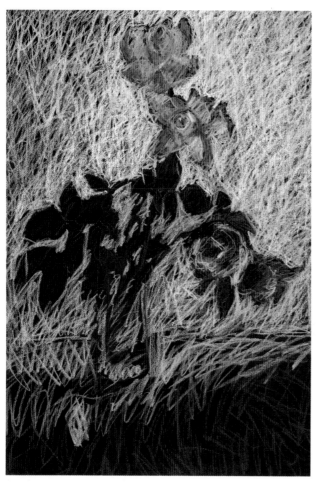

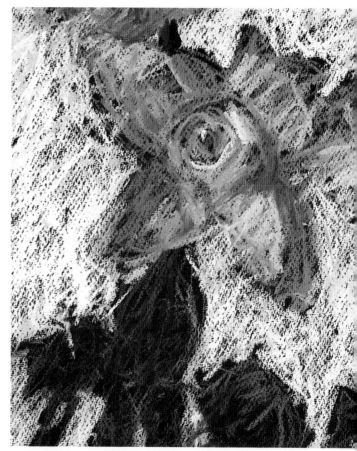

Step 4. *At this stage I was building my colors with successive layers of crosshatching, scribbling over and over the surface with many different colors. From a distance the effect is of solid color, but up close each stroke is visible, the texture creating a very interesting surface. Usually I work over the entire composition of a painting, but in this case I concentrated on the flowers first, then the background, then the rest.*

Finished painting. *In the final painting (opposite) you can see how I used unexpected colors to create a more interesting image. Look at the accents of blue in the flowers. Notice also that the leaves, which we know are actually green, are painted with blue, ochre, red, and violet as well as green.*

The detail of the roses (above, right) shows more clearly how many different colors and strokes make up each small section of the painting. I rely heavily on optical blending; rather than blending the colors with my finger, I let the viewer's eye blend them. This keeps each color fresher and more vibrant.

The detail at right shows the looseness of the stroke in the background. Even in an area that reads as solid color, there actually are many individual lines of color next to or on top of one another. Notice also how the heavily textured paper adds to the richness of the surface.

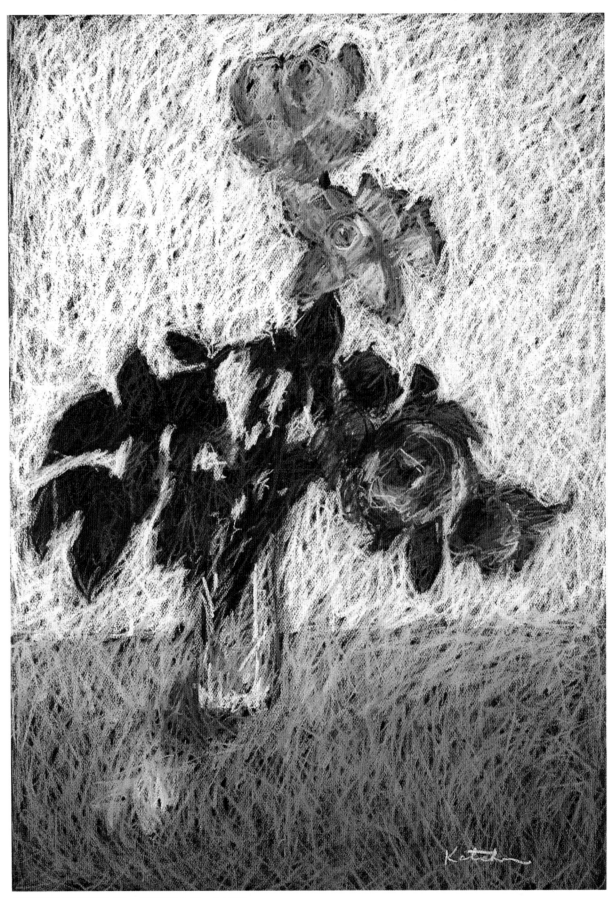

CASCADE OF ROSES, *39" × 27½" (99 × 70 cm), pastel*

Building Color in Watercolor

I was commissioned to paint a jazz club that was about to be renovated. The whole neighborhood looked rather dismal when I arrived to do my first sketches, with bums leaning in the doorway and lying on the sidewalk. The architect who hired me told me just to ignore what the neighborhood looked like and paint the club as it would be when it was finished.

The architecture was to remain basically the same, so I began my research by drawing the building itself. I used a number of drawings to show architectural details. Then I did a loose sketch of the entrance to the club, the street, and some figures. The purpose of this study was to work out basic composition and see what information I still needed.

The main thing I needed was people, chic-looking folks walking toward the club. I took my drawing materials to a downtown mall during lunch hour, where I found unlimited models for the figures in my painting.

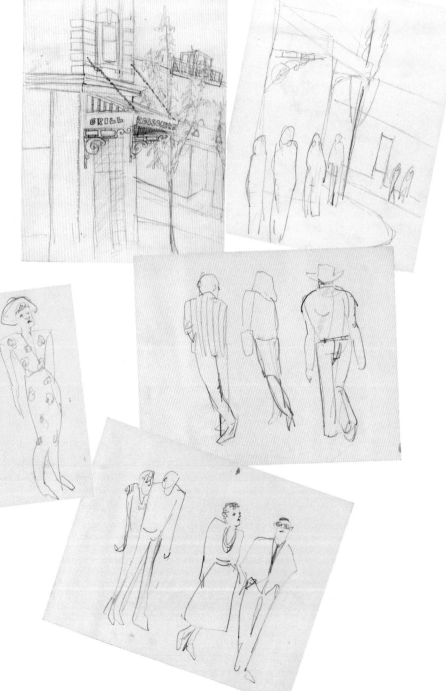

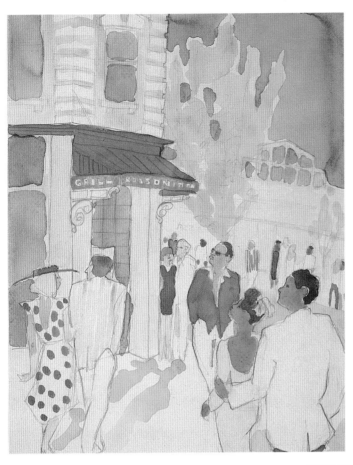

I did this quick watercolor study to finalize the composition, work out the placement and gestures of the figures, and especially to try out colors. I decided that this basic composition would work, but the values needed to be darker to make it look more like a night scene. In a color study I am not so much concerned with capturing the exact colors of the final piece, but rather to explore the possibilities.

Step 1. As usual I started with a pencil drawing to mark all the shapes. Since my client was an architect, I put special effort into making the lines straight and the corners square. This was a night scene, so I concentrated on building values from the beginning. I mixed purple for my "mother color," the color I used for the underpainting.

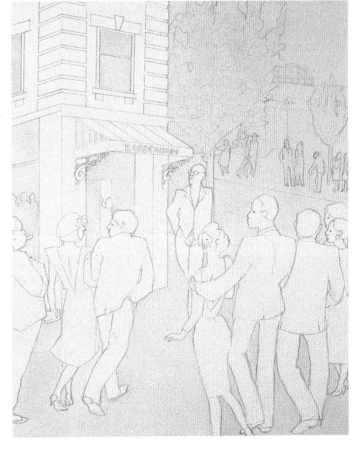

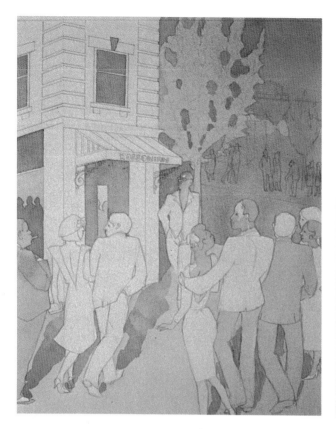

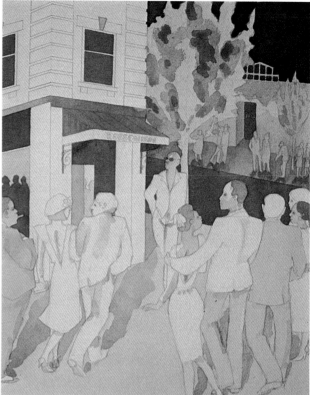

Step 2. *By adding more glazes, or thin washes, of the same color, I began to subdivide the large shapes. I look at the pattern of abstract shapes as I work; I want the composition to hold up no matter what the subject matter is.*

Step 3. *I am working toward nighttime values. Look at the darkness of the sky. I build blues by layering washes; that is, I paint a wash, let it dry, then paint another on top of it. I continue the process until the area is as dark as I want it.*

Step 4. *Here I began to focus on shadows. I also added more dark areas to balance the dark of the sky.*

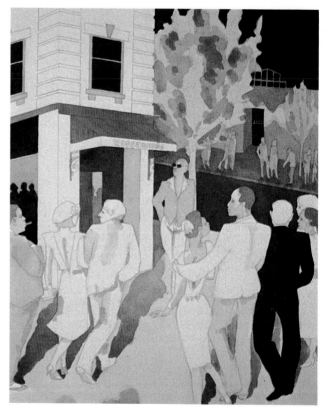

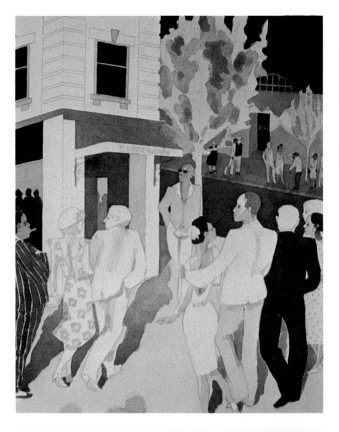

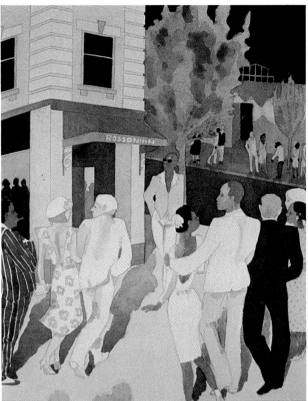

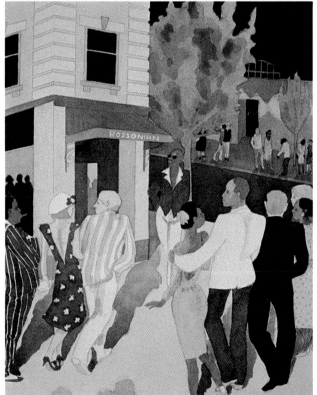

Step 5. *I added patterns to the clothing and continued to build values. Notice that I was developing the whole painting at once rather than completing one section at a time. This made it easier to balance the values in the total composition. I finally achieved my darkest darks. Notice how dramatically they contrast with the lightest areas where there is untouched paper.*

Step 6. *Once the values were set, I began to add local color. I added only a few colors, using each one in several places to maintain color harmony. For instance, the same orange from the building was diluted and used again in the Caucasian skin.*

Step 7. *At this point I expanded my palette, adding red, red violet, and aqua. The purple underpainting helped maintain the general color harmony.*

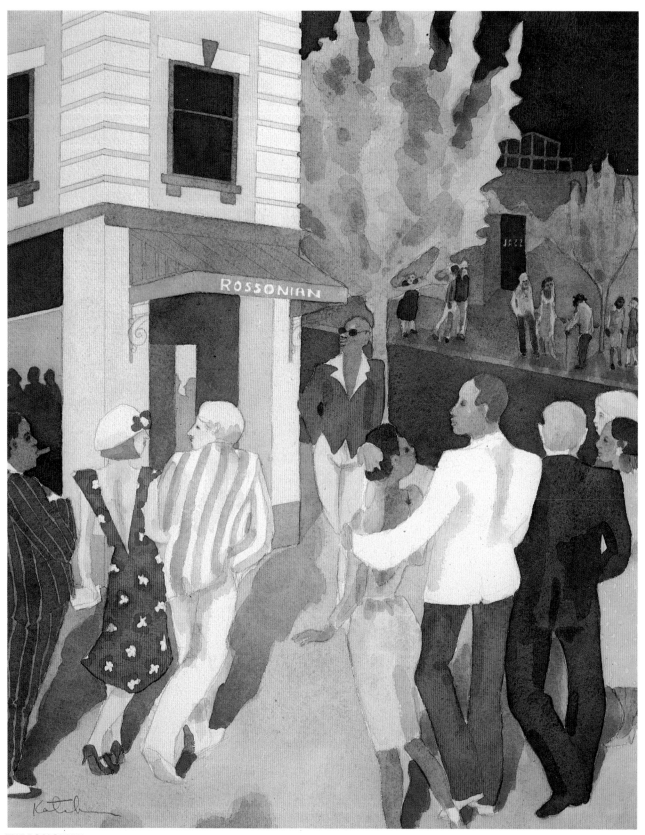

THE ROSSONIAN, *20″ × 16″ (51 × 41 cm), watercolor, collection Michael Murphy*

Finished painting. *In the final step I darkened things a bit more, especially those areas that appear farthest away. I added aqua to the trees and shadows to give the whole painting more punch, and also refined all the details.*

Painting with Complements

Choose two complementary colors—red and green, blue and orange, or purple and yellow. With just those two colors on white paper, develop a total image. Watercolor works especially well for this exercise.

Start out with very light values, light washes of each of the two basic colors and also the grays that you can achieve by mixing them together. Slowly build your colors to greater intensity by building layers of washes. For your darkest values use the same colors applied in many layers.

By using a wide variety of values of each of the colors and the grays, you can create the impression of a very colorful piece of art, one that appears to have many more than just two colors in it.

The purpose of this exercise is to help you see how much color you can create with a very simple palette.

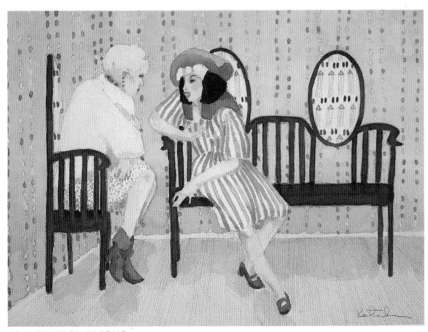

People are surprised to learn that this painting was executed with only two colors—the complementaries sap green and alizarin crimson. You can see the pure colors within the fabric pattern of the loveseat. The other colors in the painting are either lighter values of these same colors or mixtures of the two, achieved either by mixing on the palette or by layering washes on the paper. In all watercolors the white areas are important, but they are especially significant when the palette is so limited.

CONVERSATION IN SOHO, *9″ × 12″ (23 × 30 cm), watercolor, courtesy Gallery of the Southwest, Taos, NM*

111

5 Executing the Final Painting

You might expect the chapter on executing the painting to be the most complex chapter in the book. If you have succeeded in planning your painting, however, the painting is practically done.

Let's review what happens before reaching this final stage.

You start by choosing a strong subject. It is an idea that provides an image that has good composition, value contrast, and color. Moreover, it is a subject that interests you enough so that you will enjoy exploring all of its facets.

Next you take the time to research the image. You know the importance of looking at and thinking about the subject before you begin to render it. You study the main objects or figures, the lighting, the models, the background and props—all the elements that will be part of the total image.

After you gain a solid sense of how the image looks, you begin to develop the structure of the painting. The possibilities for composing any piece are limitless. Where will you place the main shapes? How big should they be? How will you arrange the smaller shapes?

At this point you are concerned with abstract forms, achieving balance and movement just with your arrangement of simple shapes.

In planning your composition you also are led to consider value contrast. The planning of your lights and darks further develops balance and movement and also gives definition to the forms and provides visual interest.

After working out your image in black and white, you begin to formalize color. Of course, you have been considering color from the very beginning; it is significant in choosing your subject. However, in your color studies you develop your palette, selecting the exact colors that will be the foundation of your painting. If you are unclear about which medium and technique you want to use for the finished painting, you can use the color studies to explore those possibilities as well.

This is where you are now. What comes next?

Studying Your Studies

At this point it is time to stop again, to analyze what you have already done. One of the hardest things for me to learn when I first began to plan my paintings was that spontaneity does not require rushing. In the paintings of mine that look the most spontaneous, I took plenty of time to develop all aspects of the piece.

One bold, exciting line, one sparkling highlight, one dot of unexpected color—these are the things that make a piece look spontaneous, and they only work if you put them in exactly the right place. Throughout the entire process you must allow yourself the time to look and think so that you will know the right place for every element in your painting.

Before you begin your final work, tack all your studies to the wall. Take the time to evaluate what you have already done. What worked best in the value studies? In the color studies? What didn't work? Decide which elements you want to keep, discard, enhance, or diminish. Now you are ready to begin the painting.

JOSEPH, THE DANCER,
39" × 27½" (99 × 70 cm), pastel

The first step in executing any painting is choosing the right subject. I am always interested in dancers. I have shown them spinning, leaping, stretching, and twisting, but I had never painted a dancer sprawled out during a break. This was a great subject because of the contrast of the heavily muscled body and the soft, easy pose. Also the light from the rear windows offered a chance for dramatic highlights.

I use painting media in whatever way will enhance the image I am creating. Oil allows for great variety. For this jazz bass player in a smoky bar, I needed to use strong colors and bold brushstrokes. In the background where the figures are more abstract, I painted layers of thin glazes. For the musician in the spotlight I used brighter colors and strong, vital strokes of oil and pastel.

JAZZ BASS, 30" × 24" (76 × 61 cm), oil and pastel, collection Sanford D. Kaiser

HARRY'S FUR COAT,
39" × 27½" (99 × 70 cm),
pastel, collection of the artist

Often I build colors slowly, adding layer upon layer of paint. In this piece the first colors I laid down seemed complete. I did some blending in the face and the coat, but otherwise the colors were right with the first stroke. I stopped and looked at the portrait for a long time, thinking that it had been too easy, that there must be more that I had to do. But, no, it was definitely finished.

What is important about this painting is that it was *easy. I had already done several studies, so I was familiar with how the model looked. The setting was my studio, so it was easy for me to organize the shapes. I took care in picking out my colors, choosing a palette that provided harmony and contrast as well as variety in values. I had already done all the hard work, so of course the execution was easy.*

Selecting Materials

In choosing materials, I am concerned with two questions: Are they permanent and compatible with each other? And will they enable me to create the image I have been planning?

I shared a studio once with an artist who used the cheapest materials he could get. He executed large canvases with housepaint and crayolas. They looked great when he finished, and his attitude was, if they fall apart in fifty years, who cares?

It didn't take fifty years. About three years after he sold a large painting for $10,000, it began literally to fall apart. The buyer was angry and the dealer embarrassed, and both the artist's and the dealer's reputations were left somewhat tarnished.

For me there is another reason to care about the quality of materials. I want each piece of my art to have an integrity. I choose only subjects I care about, and I work hard to make each painting as good as I possibly can. That is why I put so much effort into planning every painting. Using the finest materials is another form of commitment.

How do I know what materials are permanent? I seek the opinions of others—art supply dealers, other artists, curators, and conservationists—whomever seems knowledgeable. I read the descriptive material manufacturers provide about their products. I also refer to articles and books about materials. A good, new book by an art supply dealer, framer, and former chemist is *Art Hardware* by Steven Saitzyk (Watson-Guptill Publications, 1987).

There are some tests you can do yourself. To test papers, paints, and chalks for color permanence, take a sample of the paper or the pigment applied to the paper. Cover half of it with an opaque paper or board. Then place the sample where it will be exposed to sunlight. Check for fading every day for several days. Most colors will fade somewhat in direct sunlight, but some materials will lose most or all of their color in a very short time. They are the ones to avoid.

There are kits available to test paper for acid content.

I am always concerned about the permanence of my materials. I use high-quality colors even for painting studies. This little watercolor was going to be a color study for a larger painting, but when I finished it, I realized the image was as strong as it could be. I framed it and hung it in my own home, grateful that I had used good paper and paints. Why invest the time and effort in creating an image that will fade or disintegrate?

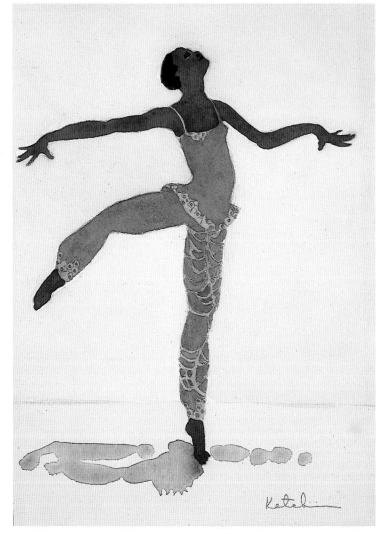

MARCIE, *9″ × 7″ (23 × 18 cm), watercolor, collection of the artist*

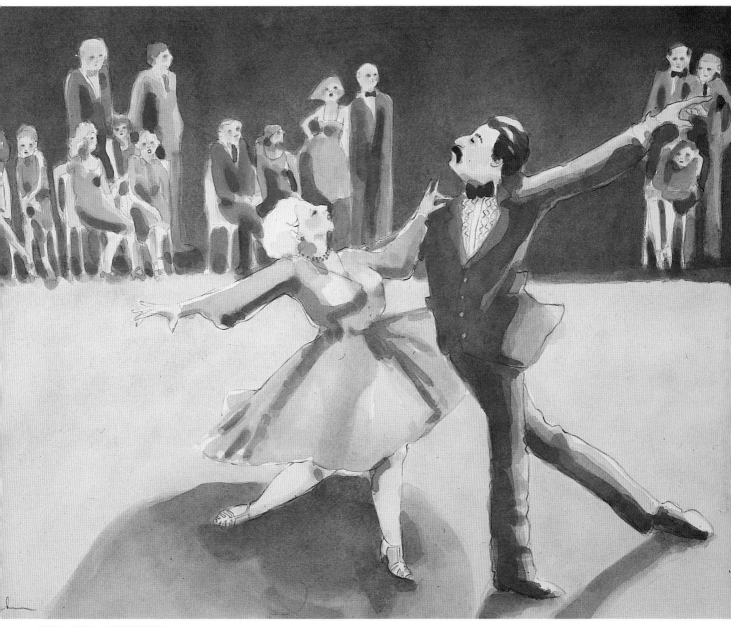

THE DANCE COMPETITION, *18″ × 24″ (46 × 61 cm), watercolor*

In this piece we can see an effective use of value contrast. The composition hinges on the division of the background into three large shapes: the dark rectangle at the top, the light value of the floor, and the middle-value shadows on the bottom. The dramatic lighting, especially obvious in the male figure, contributes to the theatrical mood. Then there is the strong abstract pattern of lights and darks in the small figures of the background. The diagram shows the abstract pattern of values as it developed in the finished painting.

These three paintings show how the same image takes on a totally different feeling when it is developed in different media. Each medium has its own characteristics. Experimenting is the best way to learn what effects can be produced for a particular image.

This small watercolor was basically a color study to help me work out my initial arrangement of colors and shapes. I was using the medium in a simple, flat way. Consequently, the image appears as a pattern of basic flat shapes. One good effect of the fluid watercolor is the soft blending of pink into blue in the water and sky.

MARSH SUNRISE, *10″ × 14″ (25 × 36 cm), watercolor, courtesy William Havu Fine Arts, Denver*

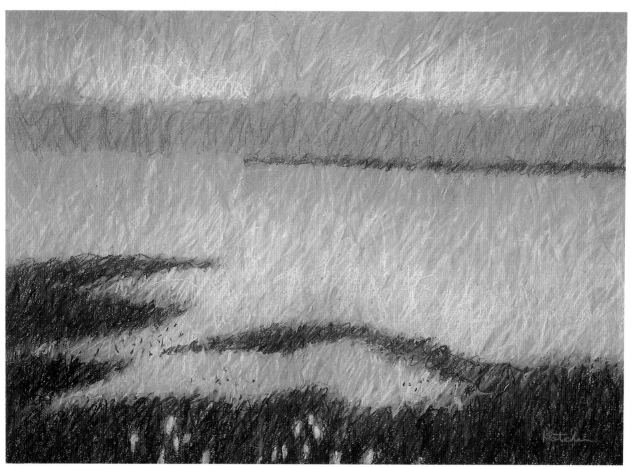

MARSH SUNRISE, *27½″ × 39″ (70 × 99 cm), pastel, courtesy Lizardi-Harp Gallery, Pasadena*

Here the color is bolder and the surface texture more lively. It is possible to apply pastel in smooth, flat colors, but I like the vibrancy of crosshatching, where individual strokes of color are left to blend optically. Although I established greater variations of color within each shape, the overall effect is still fairly flat.

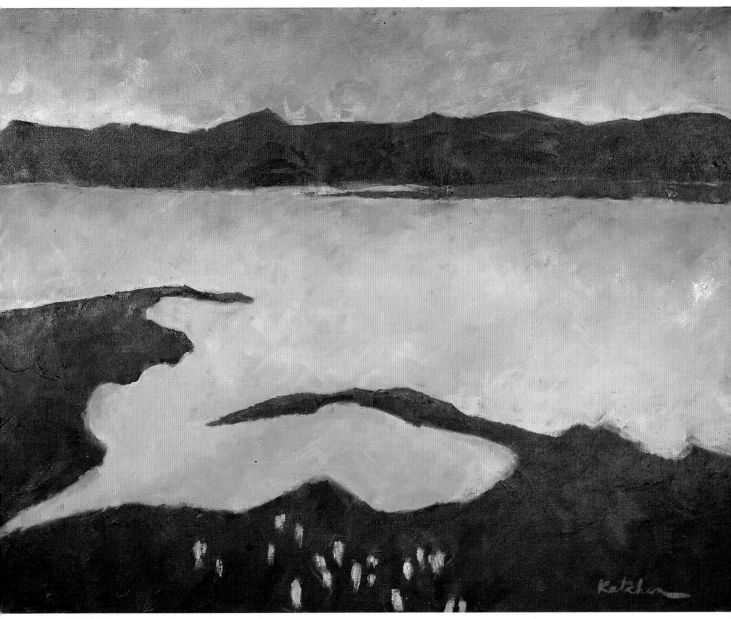

MARSH SUNRISE, *36″ × 48″ (91 × 122 cm), oil, courtesy Lizardi-Harp Gallery, Pasadena*

For the oil version I mixed my pigments with a large amount of the medium Liquin so I could achieve a fair amount of transparency. There are still individual strokes visible, but the color blending is much more subtle than in the pastels. This allows a greater sense of depth within the painting. Notice how much more solid the mountains seem and how the water appears to recede.

Avoid using any paper that is not acid-free. Papers like newsprint that have a measurable wood-pulp content discolor and eventually disintegrate.

Also beware of using acrylic-based products over oil-based products. They may seem to adhere, but the bond is not permanent and in time the top layer will probably slide right off. Oil over acrylic is usually all right if the acrylic has dried first.

The second consideration in choosing materials is whether or not they will help you achieve the final effect you want. Are they opaque or transparent? Do they dry quickly or slowly? You learn just what you can expect from watercolors, pastels, oils, or acrylics by practicing with them. Use a variety of media for your studies and try a variety of techniques with each one.

By the time you have done all the preparation for your painting, you should know if you want soft or intense colors, transparent or opaque paint, thin washes or heavy impastos. Choose the medium that will make it easiest for you to attain the image you desire.

Preparing the Surface

Once you decide on the medium, you are ready to prepare the surface. For water media there are many good papers to stretch or mount dry. For pastels most artists use a drawing paper with a tooth, or texture, to hold the pastel on the paper; pastel also works well on Masonite panels prepared with gesso and ground pumice.

Oil and acrylic paints offer more options. You can prepare a wood or Masonite board with gesso, applied in whatever smoothness or texture you prefer. You can glue canvas onto a panel or stretch canvas onto a frame. The canvas can be primed with gesso or given a more classical treatment of sizing and paint. Acrylic can also be painted on paper.

For specific instruction in how to choose and prepare a surface, you should seek out classes and other publications. Try many surfaces in your preliminary studies, and in your final painting use the one that has worked best for you.

Transferring the Image

By this time you have drawn your basic image at least once, maybe several times. If you have drawn it successfully, how do you now transfer the image from your study to your painting surface?

I generally draw it freehand, looking at my studies. By the time I am finished with composition, value, and color studies, I usually know my subject well enough to draw it easily.

There are many other options. Some artists draw a "cartoon," a full-size drawing on paper, then trace the image onto the canvas with graphite paper. Some use an opaque projector, which allows them to project a study onto the canvas and then draw the projected image.

A more intricate method involves using a grid. You superimpose a grid onto your study, draw a proportional grid onto the canvas, then transfer the image by drawing one section at a time.

No matter how you transfer the image, you must stand back from the finished drawing to make sure it works on the new format. Your painting might be larger or smaller than the study; it might be more square or rectangular. You might have made some internal changes in the composition from one drawing to the other. Before you continue with the painting, see if there are any adjustments you need to make now that the drawing is on the painting surface.

Applying the Pigment

Especially when you begin to apply paint, you should continually refer back to your studies. Don't guess at where the darks and lights should go or where the color should be. Keep your studies visible, right next to the easel if possible, and use them as a guide.

The ways of applying color are infinite. Some artists like to blend their colors for a totally smooth finish; others like every stroke to be obvious. Some artists like to apply their paint in thin glazes; others use heavy impastos. The right way to paint is the way that is most comfortable and most effective for the images you are trying to produce.

After all of the preliminary work that you have done, you should feel that you are in control. You know everything you need to know to complete your painting. You know where to put your darks and lights, where to place your colors. You understand the principles of balance and movement, harmony and contrast. You know how to apply your paint. You only need to do what you already know how to do.

You have done all the hard work, the planning, organizing, and analyzing. Now relax and let the painting be a joy.

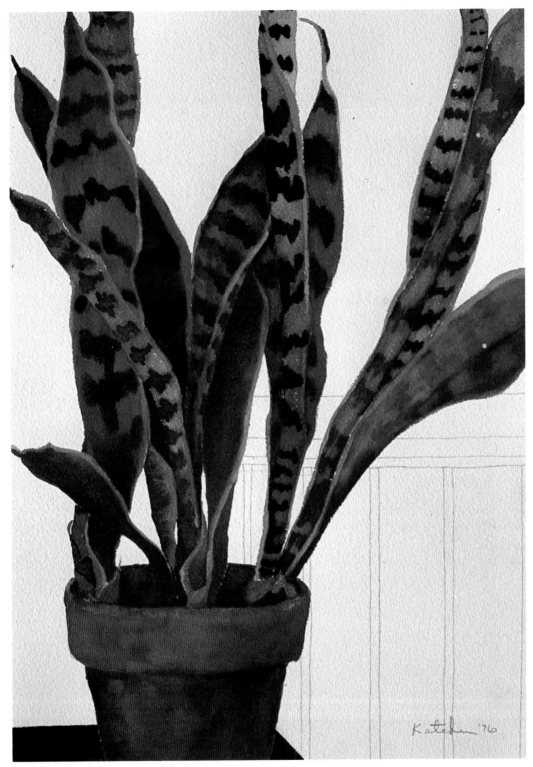

SNAKE PLANT, *14" × 11" (36 × 28 cm), watercolor*

When the problems of composition are worked out in preliminary draw-ings, the chances for executing a successful painting are greatly enhanced. This watercolor illustrates many of the qualities inherent in a good com-position. Look at the division of space: the shape of the plant is interesting and the white shapes left by the leaves also make a strong pattern. The inverted triangle of the pot and plant is anchored by the dark table top. The suggestion of wainscoating adds balance in the lower right corner, and the irregular striped pattern in the leaves adds visual interest.

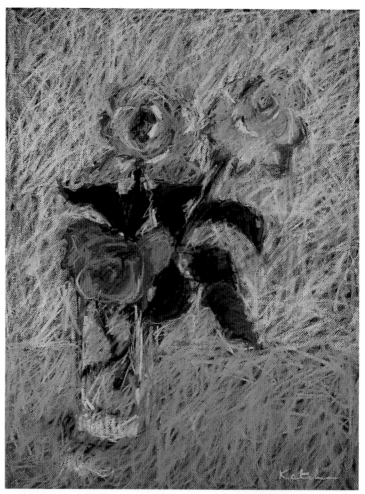

It is color that finally makes a painting sing. Before beginning a finished painting, I may make several color studies to develop my palette and decide on which medium to use.

I generally divide a composition into a few main shapes of different colors. I want the colors to work together with harmony and contrast and I also want to see a vibrancy within each area of color. In this painting basically the background is light blue, the table is brown, the leaves are green, and the flowers are pink and yellow, yet each of those color shapes is made up of many colors.

Notice especially the leaves in the detail. What is an overall effect of green from a distance actually is a combination of greens, red, yellow, and violet. Another important principle that becomes obvious in this detail is the practice of repeating colors to add to color harmony. Look at the violet strokes in the roses and leaves and the blue repeated in the flowers, foliage, and background.

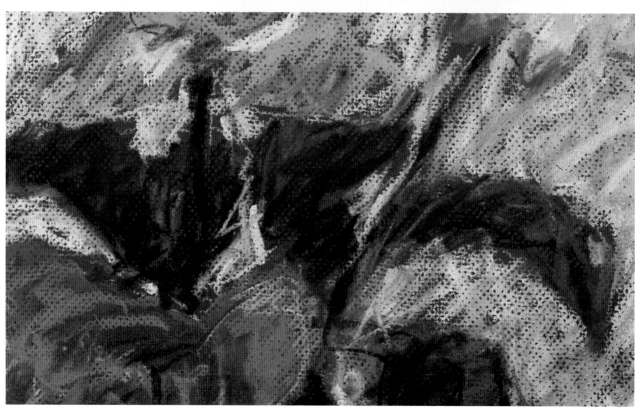

Demonstration
Painting from Studies

Some paintings, like this one, require more than one color study; others require more than one preliminary sketch. It all depends on the challenge of the subject matter. In this demonstration we take an idea all the way from quick value study through several color studies to finished painting.

Since I was working on location, my first step was to make a very quick drawing. Knowing how fast clouds and light change in the mountains, I wanted to get the basic shapes and values down as quickly as I could.

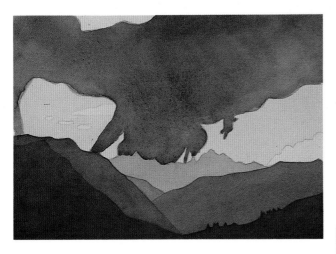

I quickly drew the contours of the scene onto my watercolor paper. With the help of my value study and my memory, I was able to complete the image, even though the view changed drastically while I was working.

In this pastel study I wanted to try an aggressive stroke and a different palette. It was a strong, interesting image, but I decided I liked the more subtle colors of the earlier version. Simpler color made the value distinctions more important.

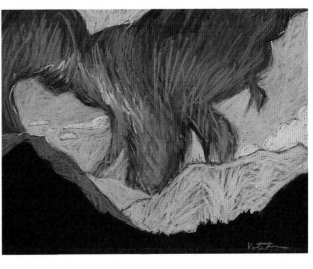

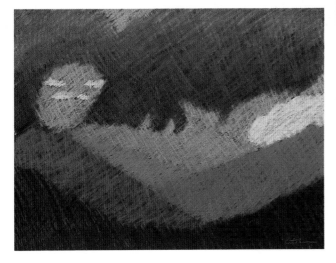

Here I went back to the original blue and brown palette, which I decided was more appropriate to the mood I wanted to create. In this study I also tried out another pastel stroke, one that gave me a diagonal, crosshatching pattern. I decided it was too geometric for mountains and clouds.

Step 1. *I drew the basic image in light blue on green pastel paper. I transferred the image from my studies freehand, looking primarily at the contours of the watercolor. I had to adjust the design somewhat to accommodate the wider format.*

Step 2. *Here I blocked in the values using a simple diagonal stroke. The lightest was in the white clouds, building up to the darkest in the foreground. At this point I left the green of the paper for the big cloud shape; I wanted to take more time to develop the values within the cloud.*

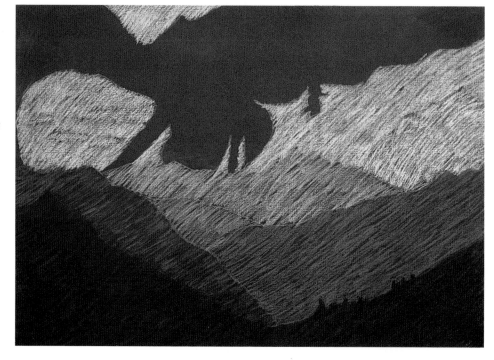

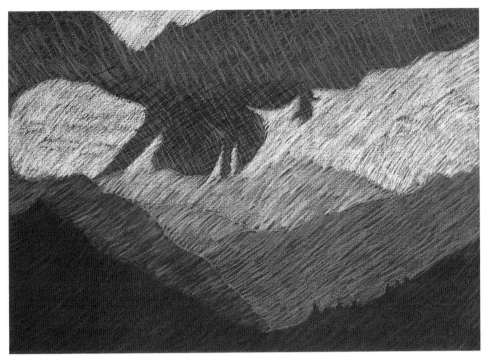

Step 3. *I began to paint the storm cloud. I wanted it to be a gray, so first I did an underpainting with orange, the complement of blue. I laid two different blues over that to start to show value.*

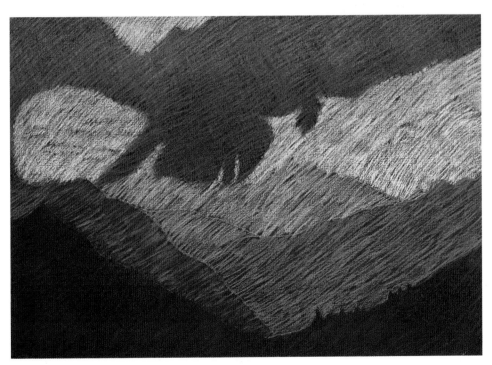

Step 4. *I continued working on the big cloud. I applied successive layers of blues and violets, alternating the direction of the stroke to create a pattern like a fine weave.*

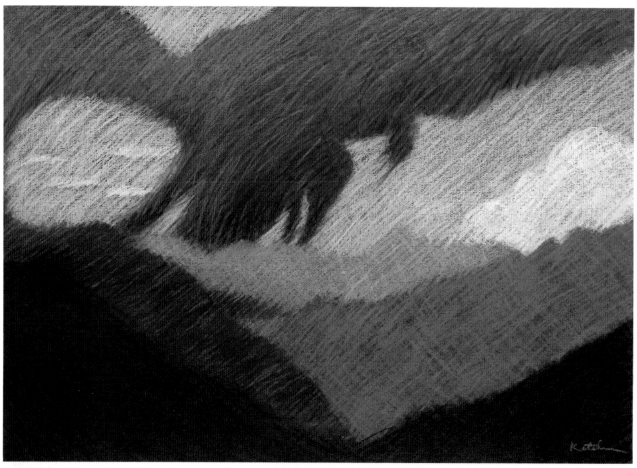

MOUNTAIN CLOUDS, *27½″ × 39″ (70 × 99 cm), pastel, courtesy Lizardi-Harp Gallery, Pasadena*

Finished painting. *Once the main shape was well on its way, I developed the other areas of the painting. I used many different colors and values of blue, green, and violet, referring often to my color studies. On some places I left a straight diagonal stroke, in others a crosshatched pattern. Because the painting was mostly composed of large, flat shapes, I felt that a variety of strokes would add visual interest. Finally I went back to the large cloud. I intensified the color and value with a bold stroke to give it more motion.*

In the detail you can see how loosely I built the colors. Only in the white clouds is the chalk fairly solid so that the light color appears brighter. I rarely use just one color to build an area of a painting. Here you can see the many different blues, lavenders, and violets I used to establish each section of color.

Demonstration

Reworking a Good Idea

Because many of my paintings are commissioned, often I must work within the limitations of someone else's wishes. This was a painting that I did just for myself, with no intention of ever selling it. It was a zany idea that made me smile when I thought of it. I smiled most of the time I painted it and I still smile whenever I see it on my wall. I think this is what painting is supposed to be all about.

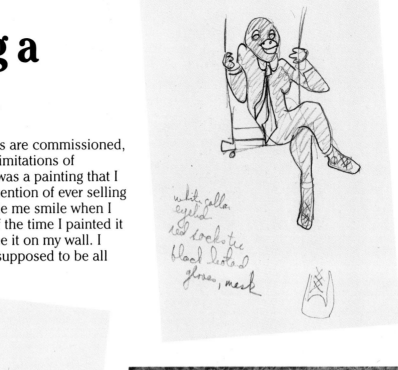

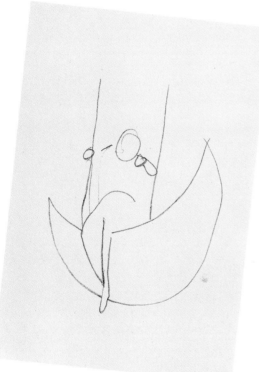

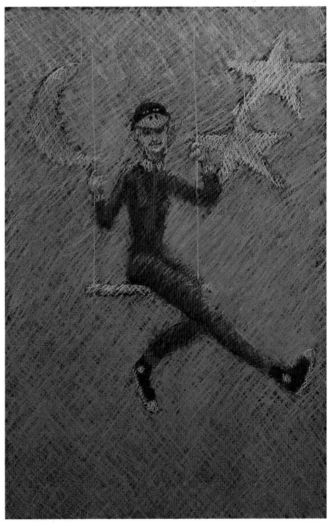

I saw this bird woman in a children's play in Houston. In the darkened auditorium I made these very quick sketches and notes on color. But as you can see, the painting that grew out of these sketches was a disaster (this is what comes of insufficient planning). The values are too dark; the division of space is bad; and the pose is boring. I threw this in the trash and started over.

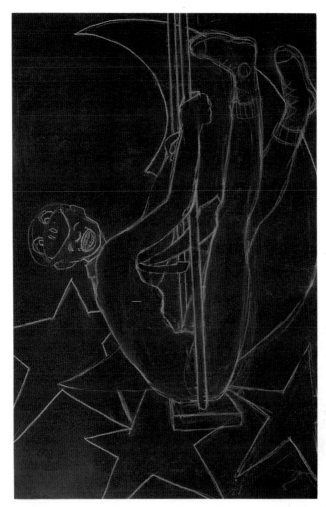

Step 1. *I drew the image again, drastically changing the pose and background. I kept the figure near the center, then in order to keep the composition from being static, I put lots of movement into the various shapes. Notice all the sharp angles.*

Step 2. *I blocked in the background colors so I could assess the shape and position of the figure. I used light colors for the whole background. I wanted the stars and moon to be obvious without overshadowing the figure.*

Step 4. *In this stage I darkened the figure with blue and purple. Also I made the background colors more solid and added blue to the moon and stars to unify them with the sky color.*

Step 3. *I blocked in the figure with a warm red. I planned to make her costume dark, but wanted to keep it warm, so I gave it the red underpainting.*

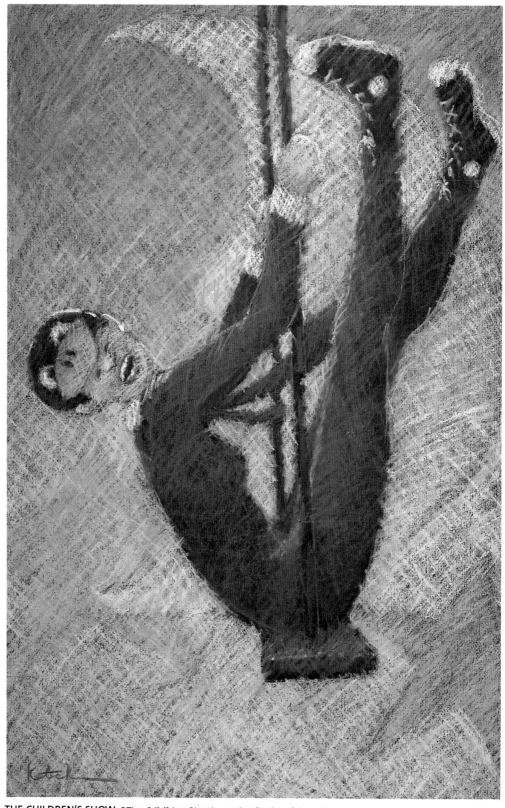

THE CHILDREN'S SHOW, *37" × 24" (94 × 61 cm), pastel, collection of the artist*

Finished painting. *In the final step I further solidified the background color. I gave the figure volume by developing the values, making the highlights warm reds and pinks, and the shadows cool blues and violets. I refined details in the costume and finished the face with an enormous smile that became the focus of the whole painting.*

Demonstration
Executing a Painting in Oil

As I drew these women in a first study, I became aware of how they sat together and talked to each other like intimate friends, but kept looking around the cafe to see who else was there. I decided to paint the idea of friends who are so comfortable together that they can look away from each other without offense.

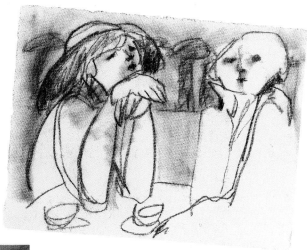

Step 1. I painted this image on stretched, oil-primed linen. I always begin my oils by painting a base color onto the canvas. This gives me a middle value to work on, which I find easier than painting on stark white. For this piece I chose green as the underpainting, then I drew my image onto the surface using a brush and blue oil paint. In this basic drawing I was careful to establish the gestures and expressions that were key to the image.

Step 2. The painting was going to be divided basically into blue and burgundy. I started with the warm color first. I painted the darkest area with the burgundy I had mixed, then I blended that color with more or less white to achieve lighter values. Even in the solid areas I used an active stroke to give the paint surface texture.

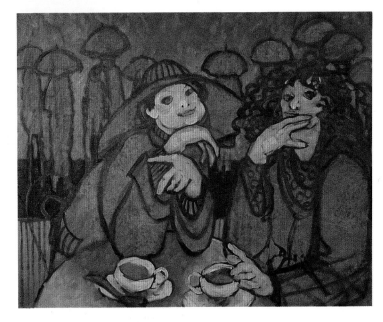

Step 3. Here I blocked in the additional colors. I used blue for the clothing, adjusting the values to give a sense of volume. I used a deep red for the background figures, a warm color that would blend with the rest of the background. Finally I added gold for dramatic contrast; I placed it in several different spots for balance.

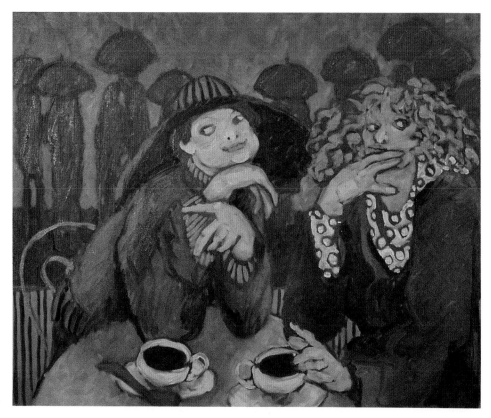

Step 4. I enriched the skin colors and used a light blue to create more dramatic lighting on the figures. Then I used the same blue in a strong hatched stroke to lighten the background and give a sense of rain. Using the same blue in background and foreground unifies the color of the total piece.

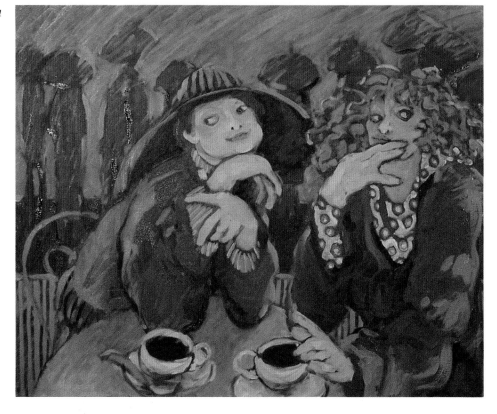

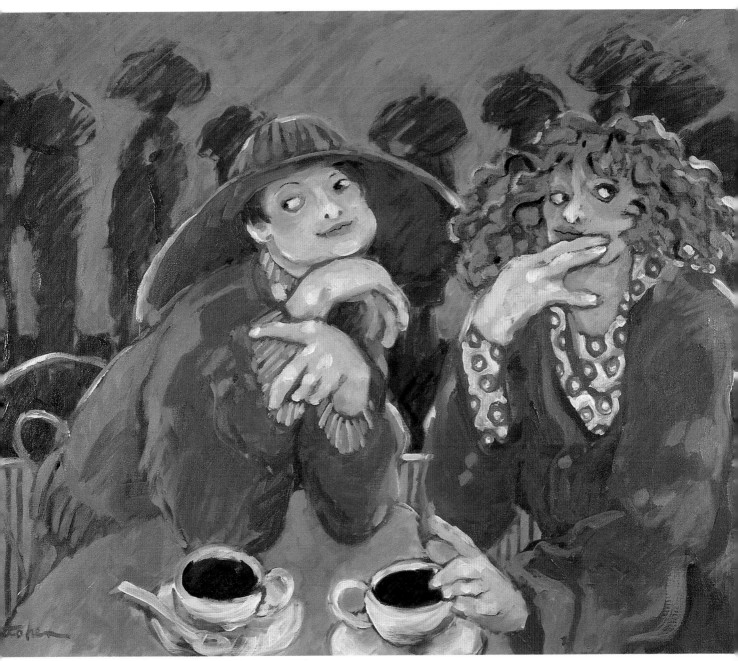

IN OUT OF THE RAIN, *24" × 30" (61 × 76 cm), oil, private collection*

Finished painting. *In the final step I added more color throughout. Accents of red, orange, pink, and purple can be seen in the hair, the clothing, and the background figures. One of the advantages of oil is that it allows a wonderful variety of strokes. Notice the many techniques used here—hatching, stippling, and scumbling, among others.*

Executing a Portrait in Pastel

For a commissioned portrait the planning process is the same—starting with studies to develop composition, value, and color and then gradually building the finished painted image. Rolf is a designer who was doing interesting things with window coverings at that time, so we worked in his house and included the knotted window curtain as a design element.

I started this piece with several loose pencil sketches to try out different poses and compositions.

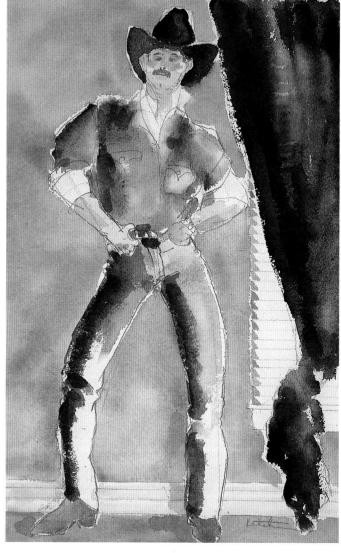

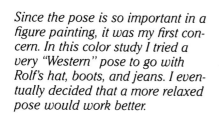

Since the pose is so important in a figure painting, it was my first concern. In this color study I tried a very "Western" pose to go with Rolf's hat, boots, and jeans. I eventually decided that a more relaxed pose would work better.

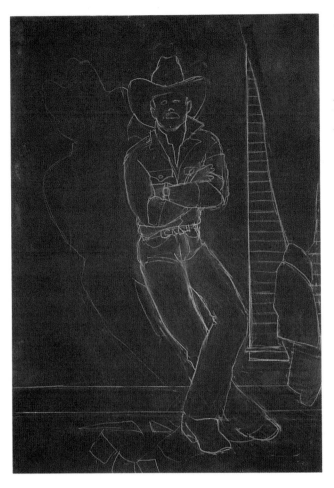

Step 1. I divided my composition into three main shapes—the window, the figure, and the cast shadow. As in all paintings, the abstract shapes are most important. I placed the shapes in the initial drawing, which was done in light pink pastel on black paper.

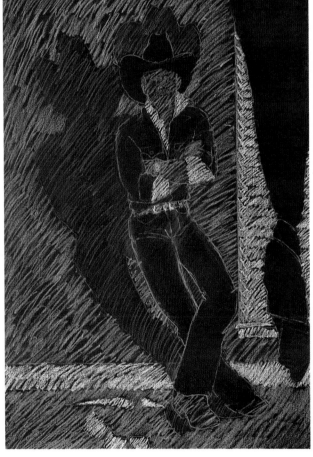

Step 2. The next step was blocking in all the basic values in light, medium, and dark colors. From the beginning I was concerned with establishing color harmony; notice the repetition of ochre in the skin, the floor, and the window trim.

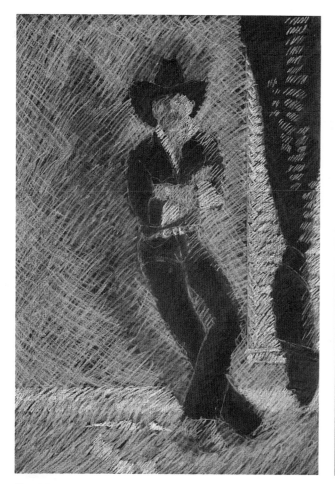

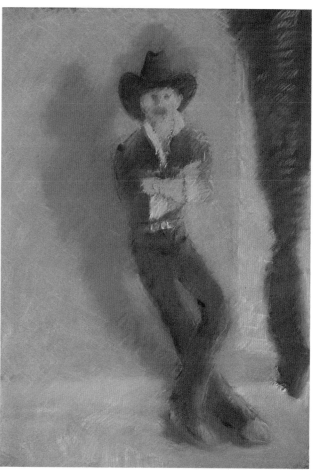

Step 3. *Light and shadow were an important part of this composition. Light from the window was throwing bright highlights on the figure and floor, and a second light source, an open door, created a large cast shadow.*

Step 4. *After building color by hatching and crosshatching layers of pastel, I blurred all the colors by lightly wiping them with a soft paper towel. I was careful not to use so much pressure that I would pull off most of my color. Also I was careful to leave separate colors within the figure rather than blending them all together. One of the reasons I like to work with pastel is its tremendous versatility.*

PORTRAIT OF ROLF,
*39" × 27½" (99 × 70 cm), pastel,
collection Rolf Seckinger*

Finished painting*. I continued to add color and wipe out color until I got just the balance of textures that I wanted. Texture is one of my main concerns in painting. Artist Pawel Kontny, a former teacher of mine, says that every square inch of a painting should be a good abstract composition in itself. One way to achieve that kind of visual interest is with texture.*

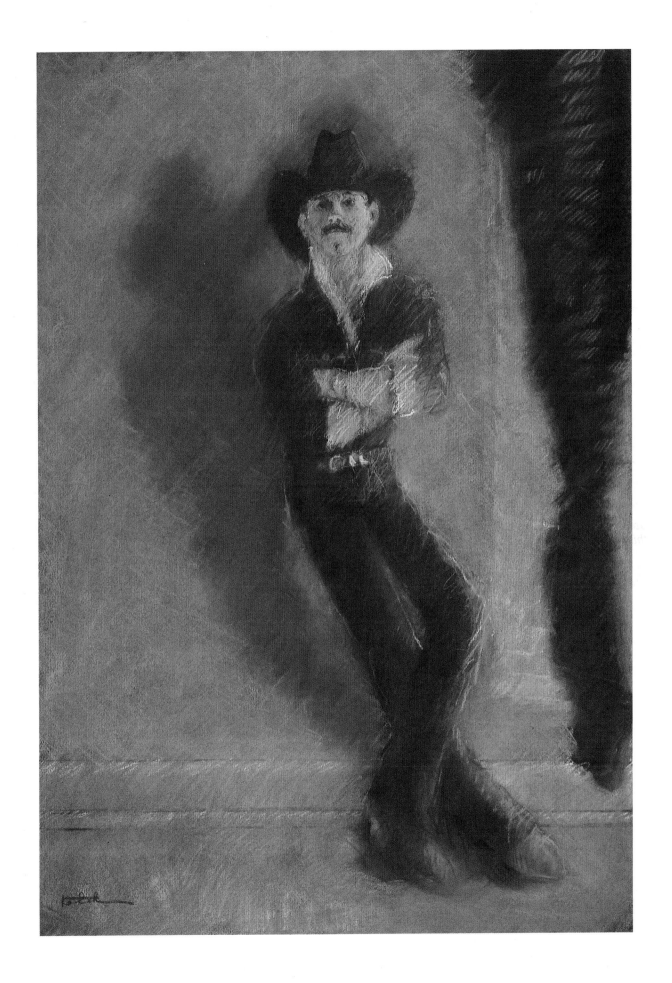

Demonstration
Using Sketches to Capture Gesture

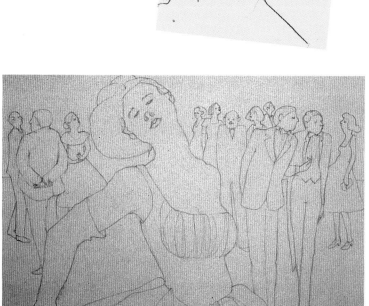

Sometimes something as simple as the tilt of a head will suggest a painting. I saw this woman at a ballroom dance competition. The way her head was tilted as if she were looking down on everyone typified her whole attitude. I thought it would be fun to try to convey that personality. I drew a quick sketch of her on the spot.

In this pencil sketch I began to fill out the composition with figures around my central character. I looked at each figure as a simple abstract shape to fit into the total design. Rather than laboring over proportion and anatomy, I let myself draw quick contours that would give some sense of gesture and personality.

Step 1. *The first step was completing the drawing of the woman and adding several figures to the background. Since she had such an exaggerated attitude, I decided to push the body language of everyone in the crowd.*

Step 2. *Here I reduced the composition to a few main shapes—the central figure, the groups of background figures, the upper negative space, and the lower negative space. I like to start painting by dividing the composition into a few large shapes. It helps with organizing value and color.*

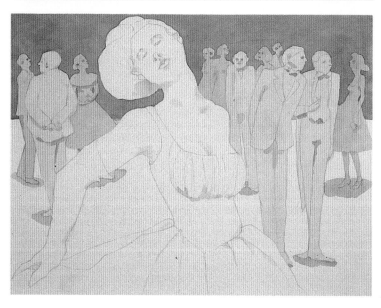

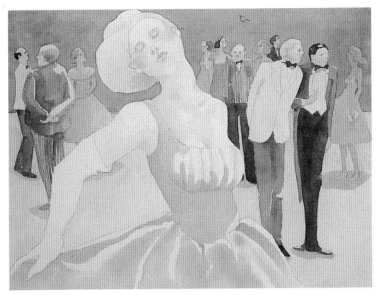

Step 3. Having used blue and violet to establish the basic values, now I added local color. Because the central figure was the only area I didn't give a cool blue or violet underpainting, it remained the brightest and warmest area of the painting.

Final painting. In the final phase I add the finishing touches—facial details and coloring and shadows throughout the painting. The central figure is the obvious focal point, but notice how much movement there is in the rest of the painting because of the activity of the other figures. Besides my main focal point, I often add secondary centers of interest to keep the eye moving.

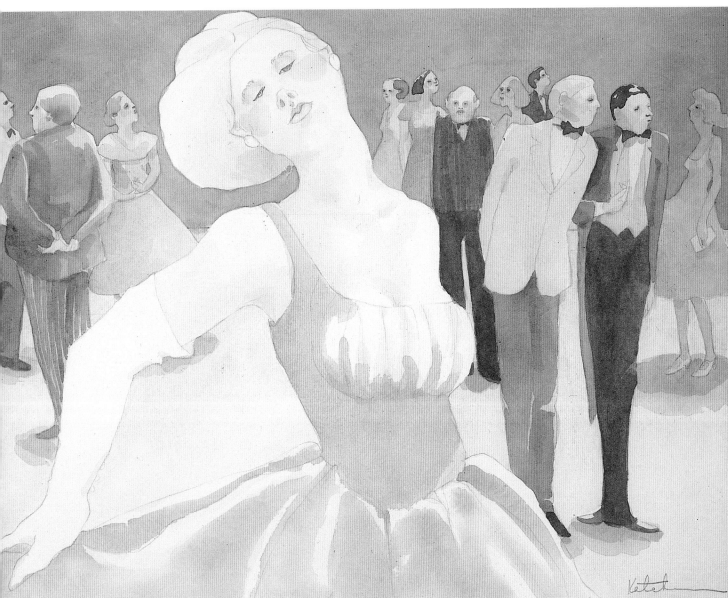

INVITATION TO DANCE, *18″ × 24″ (46 × 61 cm), watercolor, courtesy Saks Galleries, Denver*

Demonstration
Executing a Painting in Watercolor

Although my favorite pieces to paint are large, loose pastels with a broad range of colors, I also enjoy tight, controlled watercolors. Working in such a slow, precise way teaches me a lot about painting, and I find that using a limited palette as I did here pushes me to be more inventive with value and texture.

In this quick pencil sketch I experimented with the basic design of the piece. There were three main elements I was trying to organize—the buildings, the figures, and the cast shadows.

By this point I knew which shapes would go where, so I was able to focus on value. I had eliminated most of the cast shadows, but light and shadow were still important. Since the sun was shining from the rear, the figures would be the darkest element and the sky would be lightest.

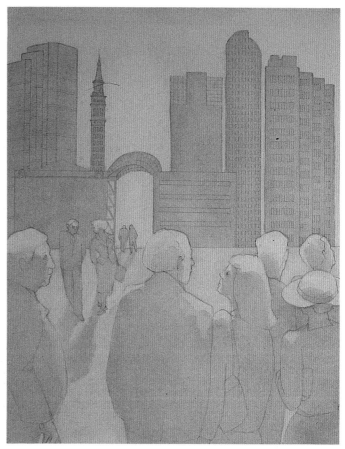

Step 1. *I started by blocking in the large shapes with color—blue for the sky, light red for the ground, and green for everything else. I left unpainted white paper for the highlights.*

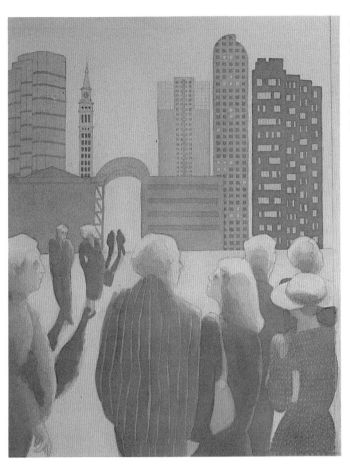

Step 2. *In this painting I was experimenting with complementary colors. Up to this point I had painted everything but the sky with washes of either green or red. I was concentrating on both value and the relationship of warm and cool colors.*

Step 3. *To develop some of the very dark values I needed, I added washes of blue, the same blue as the sky. I used the blue to paint the cast shadows and also to develop volume in the figures.*

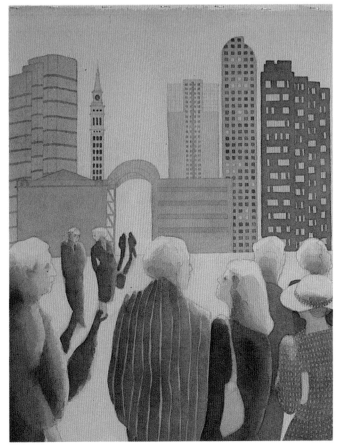

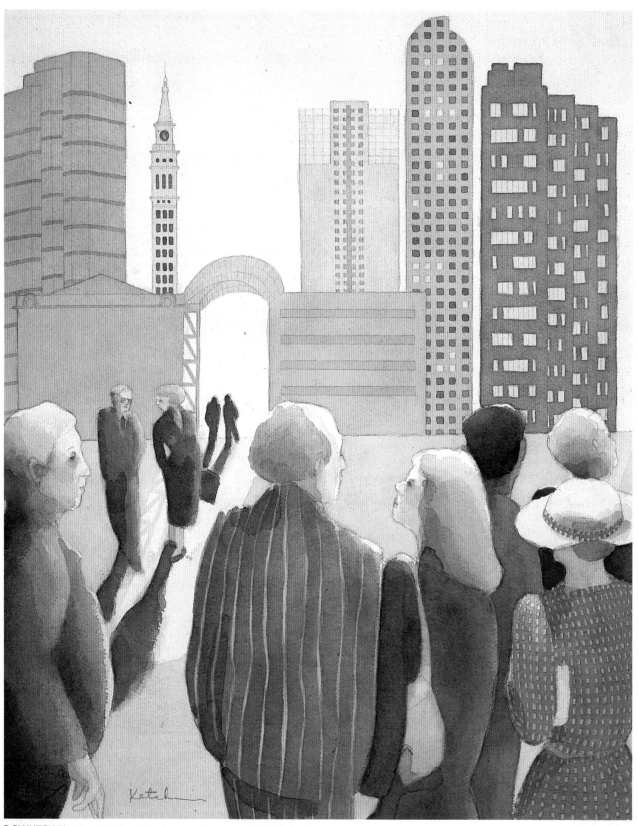

DOWNTOWN, 25" × 19" (64 × 48 cm), watercolor, courtesy Saks Galleries, Denver

Finished painting. I used the additional colors of yellow and brown for details in the last phase of the painting. All the other colors were developed from a limited palette of red, green, and blue.

Index